DURHAM
CATHEDRAL CITY
From Old Photographs

MICHAEL RICHARDSON

AMBERLEY

To My Wife Norma

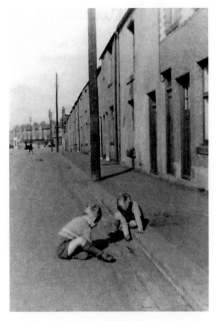

Alan and David Routledge pass the time away with a game of marbles in Bell's Ville, Gilesgate Moor, early 1950s. The picture is looking towards Sunderland Road and Kepier Crescent.

First published 1997

Amberley Publishing plc
Cirencester Road, Chalford,
Stroud, Gloucestershire, GL6 8PE

www.amberley-books.com

Copyright © Michael Richardson 2010

The right of Michael Richardson to be identified as the Author of this work has been asserted in accordance with the Copyrights, Designs and Patents Act 1988.

ISBN 978 1 84868 506 2

British Library Cataloguing in Publication Data.
A catalogue record for this book is available from the British Library.

Typeset in 10pt on 12pt Sabon.
Typesetting and Origination by FonthillMedia.
Printed in the UK.

Contents

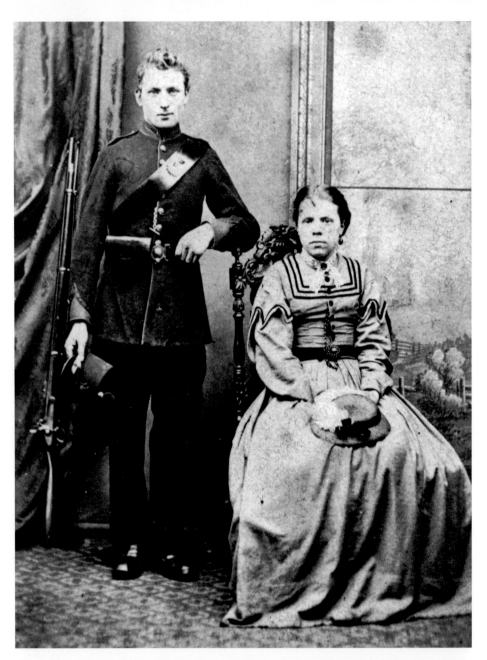

The wedding photograph of James Pearson, of Hallgarth Street, and Mary Early, November 1869, after they were married at St Margaret's Church. James is wearing the uniform of the 7th (Durham City) Rifle Volunteers, because his stepmother had confiscated the material he had bought for his wedding suit. Perhaps she disapproved of his marrying, at the early age of seventeen (from his lodgings in South Street), a bride who was four years older than himself. He started his working life as a plasterer (his father's profession), but later became gardener for the Dean and Chapter and lived in the cottage at the White Gates (see p. 38). He was later promoted to porter and lodge-keeper and the family moved to the house by the entrance arch to The College. James and Mary had eight children. This photograph was taken by J. Kirkley, 193 Gilesgate.

Introduction

This is the fourth selection from the Gilesgate Archive of photographs of Durham established by Michael Richardson. The archive is now the largest collection focusing on the people of Durham City between the 1850s and 1960s. What began as a hobby has become a significant piece of research — visual evidence is often essential in local history. The photograph is generally a reliable and truthful witness, upon occasion connecting the more usual verbal evidence, whether written or oral.

The Cathedral, the great building feat of the period 1093-1133, has dominated the history of the city of Durham. It is often forgotten that between 1662 and 1847 a solid oaken screen divided the nave from the chancel, precluding the grand Vista to which we are now accustomed. Sir George Gilbert Scott's marble and alabaster screen, completed in 1876, did no more than offer a pleasant break in the long perspective looking east. The position of the Cathedral was unique, built within the bailey of a castle. My favourite historic place in Durham is the Norman Chapel with its figured marbled sandstone columns surmounted by crude vibrant sculptures.

Education has been the outstanding service industry of the city portrait of Danny Webster, a much-loved Vice-Principal, reminds us of the importance of the former Diocesan colleges for teachers, Bede for men, St Hild's for women, established in 1839 and 1858 respectively and carefully placed across the River Wear to protect the students of the University with its colleges on the Peninsula. Durham's schools are also represented here: Durham School, with its medieval origins, was the grammar school and later the public school for boys, now sited by Pimlico; Durham High School for Girls dates from 1884; the Blue Coat School, now on a new site at Newton Hall, was founded in 1708.

Education flourished in a city centre little affected by the Industrial Revolution. The exploitation of the coalfield went on around it; it is only in the 1950s that Durham may be said to have emerged from a long period of relative decline. Where neighbouring conurbations like Sunderland and Gateshead expanded markedly, especially in the nineteenth century, Durham's population remained under 20,000 as late as 1961 and the city had a higher proportion of older and professional people than the county, or indeed the country, at large.

Portraits included in this selection highlight some of the special characteristics of the city. There is a photograph of Bishop Brook Foss Westcott (1825-1901) whose tenure of the bishopric from 1890 crowned a long life of scholarship and teaching. It was he who helped to settle the miners' strike of 1892 and who inaugurated the Cathedral service after the 'Big Meeting' of the Miners' Gala. Fittingly, his last public appearance was his address to the Gala in 1901. The picture of Mary Ann Cotton reflects the place of the prison in Durham's history; Mrs Cotton was hanged in 1873 for the murder of her stepson but she was believed to have poisoned many more. Another photograph is of Private Michael Heaviside, VC, born in Gilesgate, who in 1917 bravely took food and water to a badly wounded man stranded in no man's land for several days after the Battle of Arras. Heaviside, a miner, had been in the Boer War and was a member of the Durham Light Infantry whose history is inexorably bound up with that of the city. The pictures of William Henry Jopling and his grandson Harold commemorate the fine craftsmanship of a family still engaged in trade in the city; they each gave notable service to the Cathedral.

Other pictures record notable events in the history of the city — for example the Diamond Jubilee in 1897, the Coronation picnic of 1902, the visit of Col. W. F. Cody ('Buffalo Bill') in 1904, and Peace Day 1919. Another interesting event was the visit of the German Ambassador von Ribbentrop in 1936. At the time he was a guest of the newly elected Mayor, the Marquess of Londonderry. He was hanged after the Nuremberg trials in 1946.

It is worth observing that some of the photographs in this volume were taken by notable city photographers. The most famous of them is John Edis whose daughter continued his business for many years. A less well-known local photographer, who was Edis' master at one time and a considerable artist in his own right, was Fred Morgan. Included are a few unpublished photographs by Morgan. Each reader will have a favourite photograph in this selection, chosen perhaps for a sentimental family reason or because it evokes a memory of past experiences. Mine, chosen on purely aesthetic grounds, is Fred Morgan's study of haytime on The Racecourse. It reinforces the basically rural nature of the area around the city which gives such pleasure still to the inhabitants of Durham.

A particularly poignant photograph is that of the poet, William Noel Hodgson, son of the Bishop of St Edmundsbury, who was killed in the Battle of the Somme on 1 July 1916. He had been, at Durham School and Christ Church, Oxford. In 1915, the year before he was killed, he revisited Durham and wrote these words:

Last night dream-hearted in the Abbey's spell
We stood to sing old Simeon's passing hymn,
When sudden splendour of the sunset fell
Full on my eyes, and passed and left all dim
At once a summons and a deep farewell.

This selection of photographs will give pleasure to residents and visitors alike and makes a real contribution to our knowledge of the city.

SECTION ONE
On The Rock

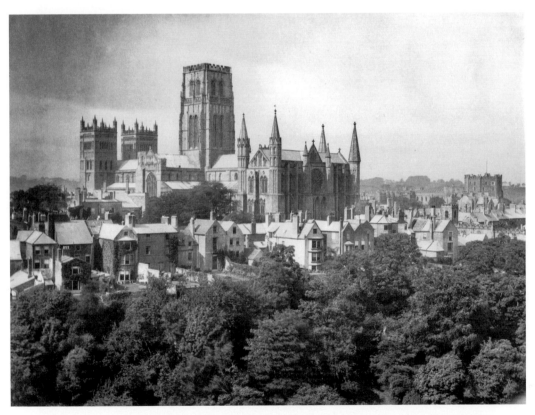

Durham Cathedral, showing property in the South Bailey, seen from the tower of St. Oswald's church, 1889. The photograph was exhibited at the 1889 Industry & Art Exhibition, Whitworth Institute, Manchester.

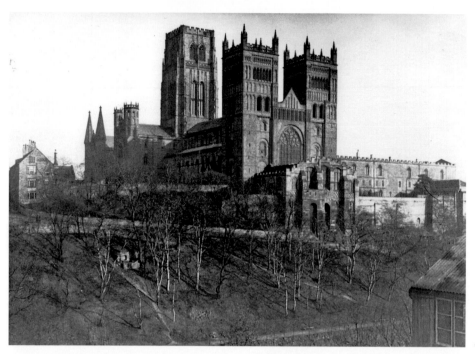

Durham Cathedral from the bottom of South Street. 1890s, showing the western towers and Galilee Chapel. To the left, on the bankside, is St. Cuthbert's Well (see below) and on the extreme left is Divinity House in Windy Gap, a footpath leading to Palace Green.

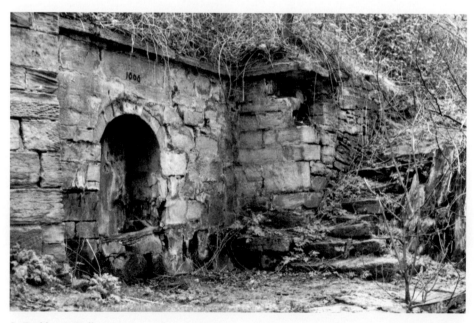

St Cuthbert's Well, as it appeared in the late 1970s, before its restoration in 1987 as part of the 1,300th anniversary of the death of St. Cuthbert (687). The Friends of Durham Cathedral paid part of the cost of the work. Above the well is its original date – 1696.

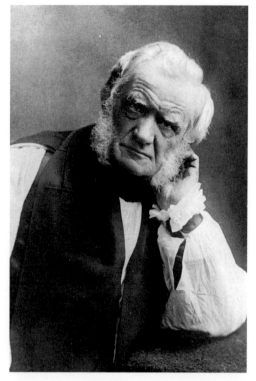

Bishop Brooke Foss Westcott, Bishop of Durham, c. 1898. A conference he called at Auckland Castle for miners' representatives and colliery owners brought about a settlement of a three-month strike in 1892. He also supported the scheme to provide free homes for aged miners. It was his idea to hold a special miners' service in the Cathedral at the 'Big Meeting', the first one being in July 1897. Unfortunately, ill-health prevented him from attending. As a result of his sympathetic attitude he was known as the 'Pitman's Bishop'. He died in 1901, aged seventy-six, and is buried in the chapel of Auckland Castle.

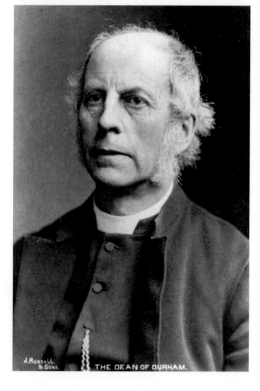

George William Kitchin, Dean of Durham, c. 1910. He was already beyond retirement age when he came to Durham from the Deanery of Winchester in 1894. His name can be seen on the foundation stone of St Oswald's Church Institute (laid in 1902). He wrote two books on local subjects towards the end of his life — *The Seven Sages of Durham* (1911) and *The Story of the Deanery of Durham, 1070-1912* (1912). He died in the latter year, aged eighty-five, and is buried in the Cathedral churchyard.

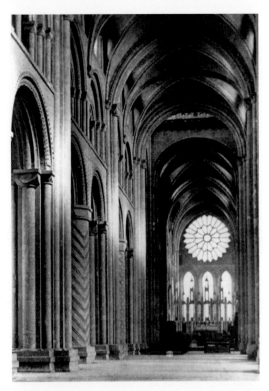

The Cathedral nave and chancel, photographed by Thomas Heaviside, *c.* 1872. The ribbed vaulting is one of the earliest examples in Europe (1128-33). The choir screen of 1662, with Father Smith's organ on top, was removed in 1847 so that 'a grand vista' could be opened up. The Neville Screen (1380) was then visible from the back of the church.

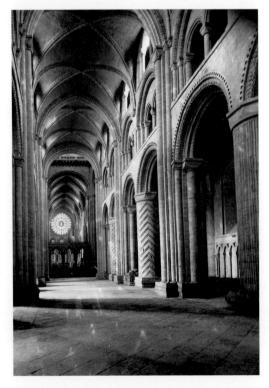

The nave and choir of the Cathedral, looking east, *c.* 1890, taken by John Edis. The marble and alabaster choir screen was completed by Sir George Gilbert Scott in 1876. The 'vista' (see above) had proved disappointing and Scott's screen was intended to rectify this mistake.

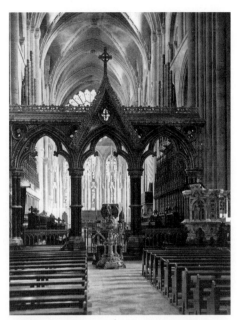

Scott's brass pelican lectern (centre), *c.* 1895, in supposed imitation of the one used in monastic times, and his ornate, Italian-style, marble pulpit (right), *c.* 1895. Both were designed at the same time as the screen. This photograph is by F. W. Morgan.

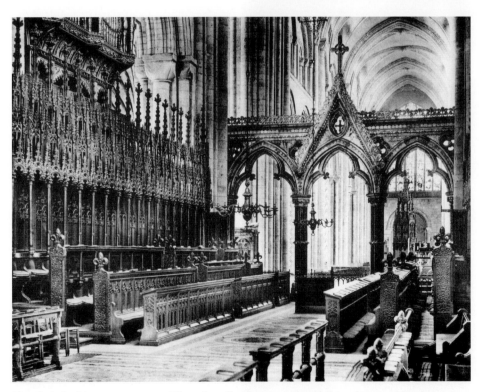

The choir looking west, *c.* 1900. The oak stalls of 1665 replaced those destroyed by the Scottish prisoners who were confined in the Cathedral after the Battle of Dunbar, 1650. In 1846, to create more seating in the choir, the canopies were cut up and set back between the pillars. They were restored to their original appearance by Scott in the 1870s.

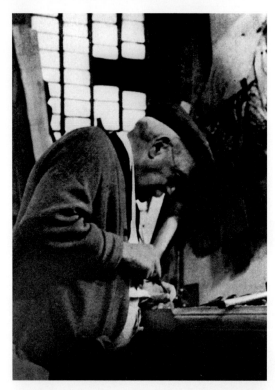

This photograph of William Henry Jopling, Cathedral carpenter, taken in about 1930, is described in the Annual Report of the Cathedral Friends as 'a fine portrait of a great old English craftsman'. One of the pair of oak doors for the shrine of St Cuthbert begun by William Jopling shortly before his death in 1935, was finished by Mr Walter Hollis. It was engraved in Latin in his memory: 'I have filled him with the spirit of God, with wisdom and intelligence and knowledge in all work, for devising whatever craftsmen can, out of ... the variety of timbers.'

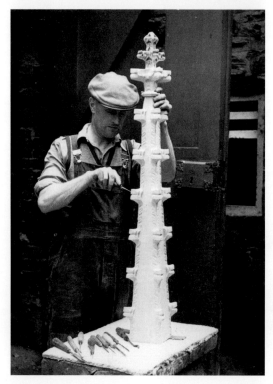

Harold Jopling, Cathedral mason, grandson of William Henry, working on a replacement pinnacle (second from the north) for the Neville Screen, May 1959. Mr Jopling joined the yard staff of the Cathedral in 1938, but soon had a break for war service with the 8th battalion, Durham Light Infantry, 1939-45. He retired in February 1982 and in the following May was presented with the British Empire Medal.

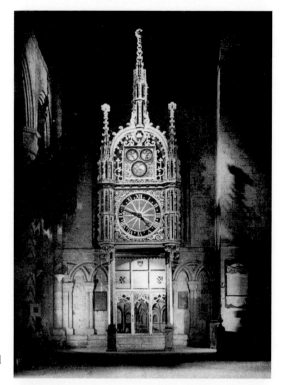

The clock provided by Prior Castell (1494-1519). It had survived the Scottish prisoners (see p. 11) — the thistle emblem is carved near the top — but it was dismantled in 1845. The photograph shows it after its restoration and return to the south transept in 1938. Below the main dial are two painted doors which lead to the slype (see below).

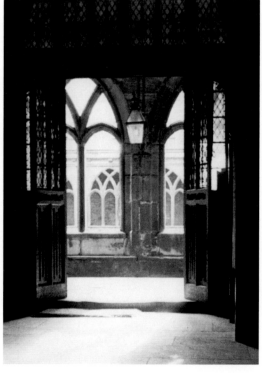

A view of the cloisters taken from within the open doors of the slype, *c.* 1937. The slype was a room between the south transept and the chapter house. Business people with goods to sell, e.g. cloth for robes, could meet the monks there, as could visiting relatives. The photographer is thought to have been Robert J. S. Bertram, Master of Design at Armstrong College, Newcastle, and producer of *Durham, A 1920 Sketchbook* (1920, reprinted 1990). He was almost certainly the 'Mr. Bertram' who coloured the heraldic shields on Bishop Hatfield's tomb, 1934-5 (Dean and Chapter minutes, 4 February 1933 and 21 July 1934).

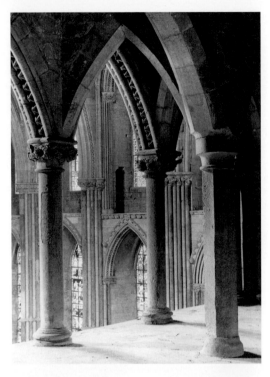

A view, at clerestory level, from the south wall of the Chapel of the Nine Altars across to the southern end of the east wall, *c.* 1890. The alternating shafts of Frosterley marble and sandstone emphasise the great height of the chapel (1242-80).

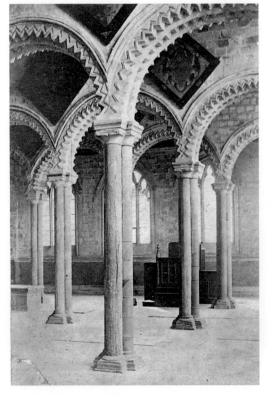

The Galilee Chapel (late Norman) from the north-west, taken by Thomas Heaviside in the 1860s. The large diamond-shaped objects on the walls (eighteenth-century hatchments-boards showing family heraldry) hung in the chapel for some years between 1843 and 1900. They were removed to the triforium until the early 1980s and are now displayed in the Monks' Dormitory and the Prior's Hall, with one more in the Treasury. Against the south wall is part of a three-decker pulpit, the main compartment of which is now on the north side of the chancel.

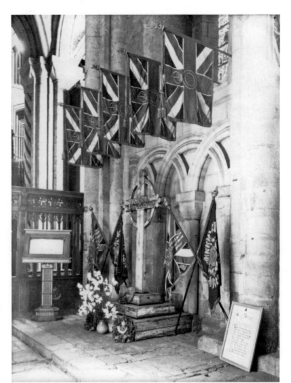

The Durham Light Infantry Chapel, c. 1943. The need for it was felt after the 1914-18 war and it was dedicated as a memorial chapel in October 1923. The wooden cross had been made and put up on the Butte (or Hill) de Warlencourt during the Battle of the Somme in 1916. It remained there until 1926, when it was brought to this chapel. Pages of the Books of Remembrance are turned daily.

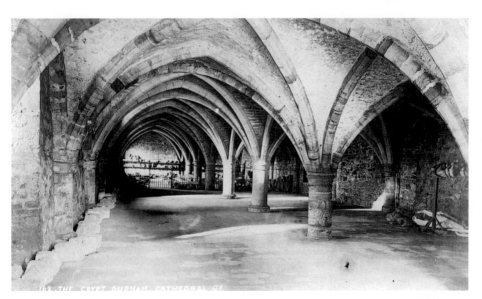

The thirteenth-century undercroft, c. 1912. It was known as the 'warming house' because a fire was lit here during the winter months. On the right can be seen 'the whale's bones', brought to Durham in 1776. (The bishops had the priviledge of claiming all whales that were washed up on their shores.) These have been a curiosity to children and visitors for centuries. Regrettably, however, they were moved to some obscure location for storage, in order to make way for the bookshop, restaurant and Treasury, 1974-8.

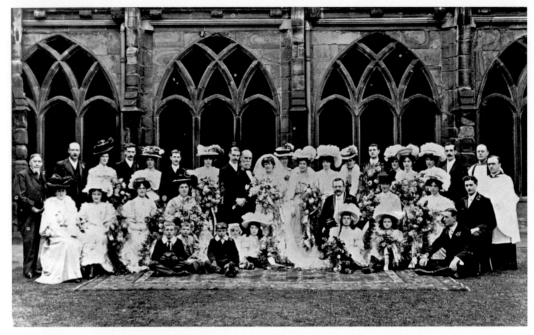

Wedding group of Miss Alice Pattison, Mayoress of Durham, and Mr Axel Theodor Morck, of Sunderland, in the cloisters, 18 September 1907. The ceremony was performed by Archdeacon Henry William Watkins, assisted by the Revd H. W. Mackenzie, Headmaster of Durham School and the Revd. F. Thomas, vicar of St Giles'. On the back row, second and third from the left, are Dr and Mrs Henry Smith, of Claypath House. Alice was the sister of the Mayor, who is seated wearing his mayoral chain. He was the owner of Pattison's Upholsterers and House Furnishers shop on Elvet bridge. Photograph by J. R. Edis.

Fred Smurthwaite, Cathedral chorister, September 1921 (brother of Mrs. E. Blyth, a former Mayor of Durham). He was born in New Elvet. This photograph was taken by S. E. Taylor of 5 Silver Street.

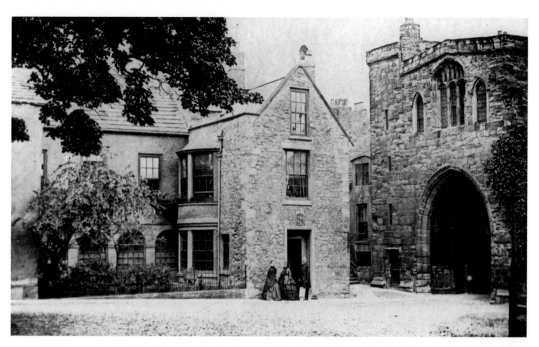

A Victorian view of the Chapter Clerk's house in The College, formerly the Chamberlain's Exchequer, c. 1880. On the right is the gateway with St Helen's Chapel above.

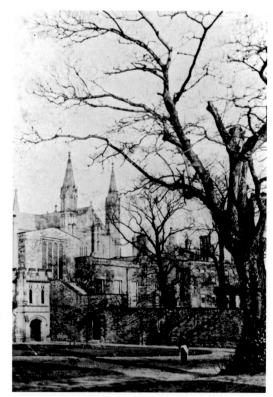

This photograph, c. 1880, shows part of the former monastic buildings. To the left is the south-east entrance to the cloisters from The College; to the right is the Deanery (once the prior's lodgings); and beyond are the turrets of the Chapel of the Nine Altars.

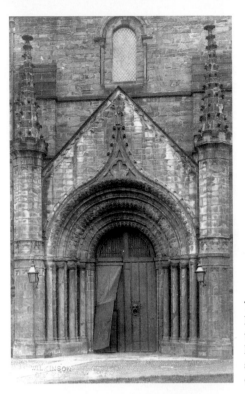

The north door, *c.* 1920, taken by W. Wilkinson. In monastic times there was a porch at this door with rooms above. Two men were always on duty here, ready to receive anyone who came to claim sanctuary. The porch was removed towards the end of the eighteenth century.

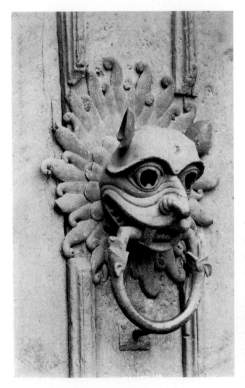

The twelfth-century bronze sanctuary knocker on the north door, *c.* 1920. It was taken down in 1978 and sent to the British Museum's Conservation Department. When returned, in January 1980, it was displayed in the Cathedral Treasury. An exact replica, made at a cost of £3,000, was placed on the north door. Sanctuary at Durham lasted for thirty-seven days. If the dispute was not settled by then, the fugitive would be given safe escort to the coast. Right of sanctuary was abolished in 1623 in the reign of James I.

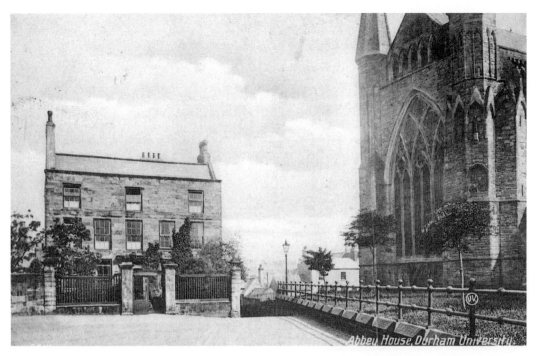

Palace Green with Abbey House on the left, *c.* 1910. To the right, on the north-west turret of the Chapel of the Nine Altars, is the carving of the Dun Cow which, supposedly, led the monks carrying the coffin of St Cuthbert to Durham in the year 995. It gives its name to Dun Cow Lane, the entrance to which can be seen (centre).

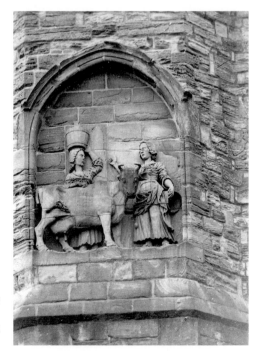

The Dun Cow carving, 1915. The first reference to the legend was in the sixteenth century. George Nicholson, the Cathedral mason and architect, replaced an earlier sculpture with his own version (seen here) in the late eighteenth century.

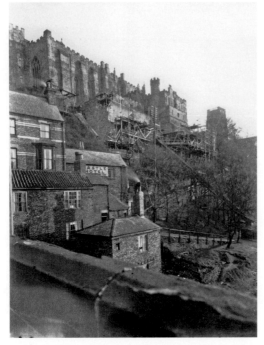

A view from Framwellgate Bridge, January 1930, showing restoration of the Castle walls. The total cost was £200,000, of which the Pilgrim Trust contributed £50,000. A plaque within the main entrance from the Castle courtyard states that the Trust, 'established by the generous benefaction of an American citizen helped to preserve Durham Castle from imminent destruction through the collapse of its foundations. AD 1930-1939. ' According to the Ordnance Survey map of 1915 the sloping path leading To the bridge was already known as 'The Broken Walls' by that date.

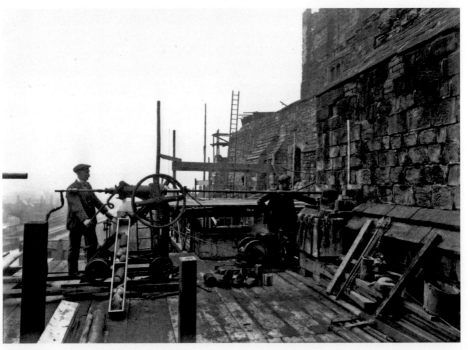

A close-up view of the drilling machine used for the huge steel rods which were fixed to secure the foundations in December 1929. Work started in 1924 on the underpinning of the foundations, when the western walls of the Great Hall (also the western curtain wall) were showing signs of serious cracking.

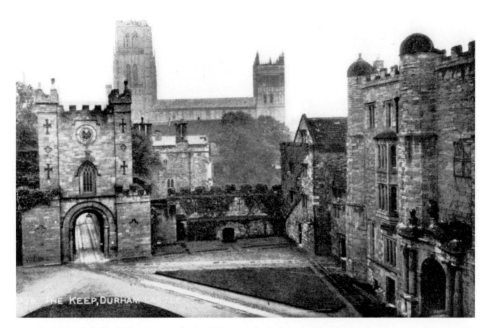

Despite being labelled 'The Keep', the building on the left is the Castle gatehouse, seen from inside the courtyard, c. 1930. The core of this building is Norman, but the tower and side-rooms were added by James Wyatt in 1791. The massive oak doors were put in by Bishop Tunstal (1530-59). To the right is Bishop Cosin's grand porch over the entrance to the Great Hall.

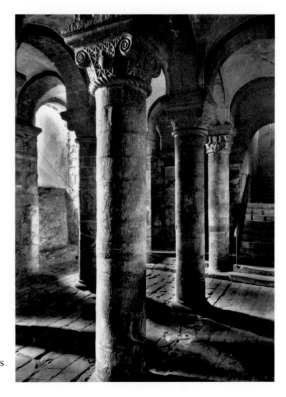

The Norman Chapel, Durham Castle, c. 1907. This ancient chapel, believed to be the oldest building in the city, was constructed at the time of William I. It was probably unused after Bishop Tunstal built his new chapel in the 1540s. the steps shown on the right of the picture were inserted when the University rebuilt the keep, in about 1840, to allow workmen to pass that way. The rest of the chapel was then used as a fuel store. It was not until 1951-2 that the steps were removed and the wall built up, so that the chapel could be restored and used again for its proper purpose. Note the capitals of the six columns showing early Norman sculptures. This postcard was produced by G. Bailes, Silver Street.

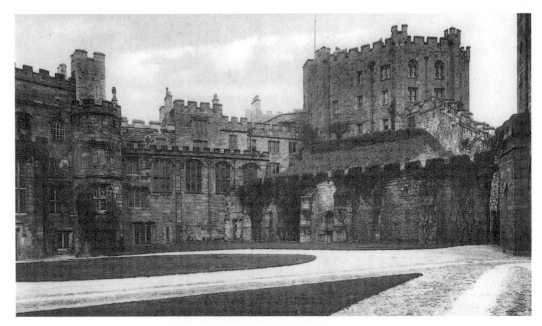

The Norman keep, seen from the courtyard, 1920s. After the Scots ceased to be a menace it was allowed to fall into ruin. It was rebuilt by Anthony Salvin, 1839-41, to provide accommodation for students of the new University College. During the work the bones of a whale (see p. 15) were found among rubbish in the crypt (i.e. the chapel).

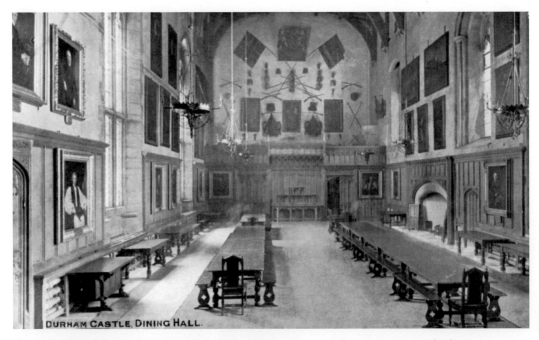

DURHAM CASTLE, DINING HALL.

The Great Hall of the Castle, 1911, built by Bishop Bek (1283-1310) showing armour and colours on the south wall above Bishop Fox's Gallery. The armour is Cromwellian helmets and breastplates. The flags are those of the Wallsend Volunteers and date from the Napoleonic Wars.

SECTION TWO
Meet The Folk

Bath time for John Slack, in the backyard at 20 Unthank Terrace, New Brancepeth, 1931. This would have been a common sight in the mining communities throughout Durham until the late 1940s, and even into the early 1950s in some rural areas.

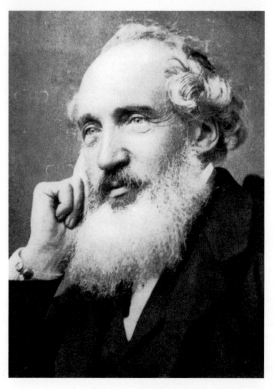

John Henderson of Leazes House, *c.* 1870. He was the eldest son of Gilbert Henderson who established a carpet factory in Back Lane, Durham, in 1813. John was a seventeen-year-old apprentice in the factory when his father died in 1824. Trustees managed the firm until he came of age. His younger brother, William, became a full partner in 1835. As Liberal MP for Durham from 1864 to 1874, John spent some of his time in London. He died on 7 April 1884 and was buried in St Nicholas' churchyard (near The Sands).

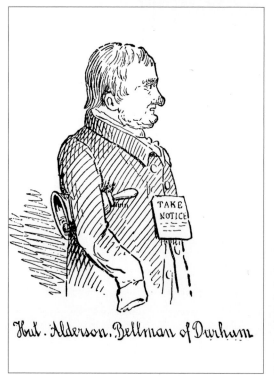

Hut. Alderson. Bellman of Durham.

An amusing Victorian sketch of Hutch Alderson, Town Crier and Bellman of the city in the 1830s (see p. 37). This was the way news was circulated before newspapers became plentiful. Hutch, a self-styled MD, was, in fact, a well-known horse doctor, a useful chap to have about when there were so many horses on the streets.

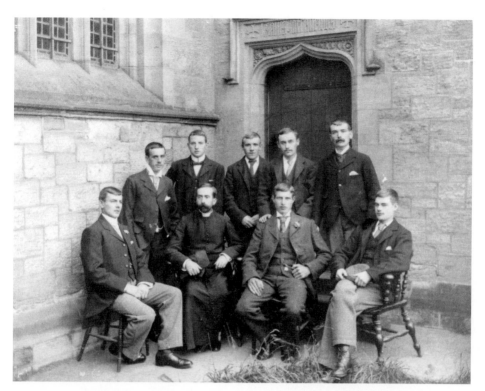

A group of gentlemen outside the vestry of St Giles' Church, photographed by John Edis, late 1890s. In the centre, seated, is the vicar, the Revd Ponsonby A. M. Sullivan. Over the door can be seen a Latin inscription, *Salus Intrantibus* – Salvation comes to those who enter.

Mr and Mrs Haswell outside their lodging house, 38 Old Elvet, 1908. The accommodation was described on the back of the postcard as 'quaint, quiet with convenient postal facilities'. It was situated to the left of the Dun Cow public house.

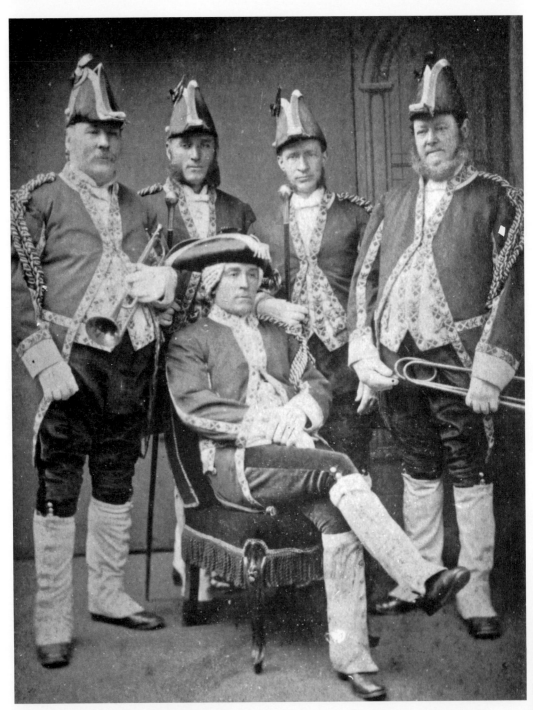

The assize court attendants, 1883. These men accompanied the Assize Judge to Court daily, from his lodgings in the Castle (see p. 98). This photograph was taken by Thomas Heaviside. Born in Durham in 1828, he was in business as a photographic artist from 1861 until his death in 1886, at first in Paradise Lane and from 1863 at 3 Owengate (Queen Street). His grandson was a notable Durham native (see p. 111).

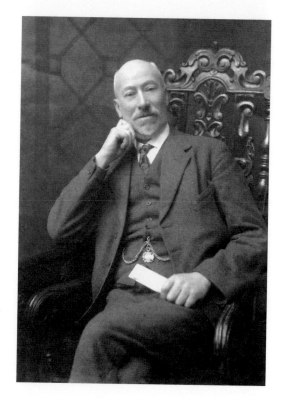

John Foster, Methodist preacher, of 71
Gilesgate, *c.* 1870 Formerly a miner, he
was described in *Wesleyan Methodism in
Durham City* by W. Thwaites, 1909, as
one of the most devoted Christians ever
associated with the movement in Durham.
He died 25 September 1883 and is buried
in St Giles' 1870 churchyard. His headstone
pays tribute to his Methodist service.

Mr T.H. Cann, who succeeded as General
Secretary of the Durham Miners' Association
on the death of John Wilson in 1915. This
photograph, a fine studio portrait by John
Edis, was probably taken in that year, when
he formally opened the new Miners Hall at
Red Hills.

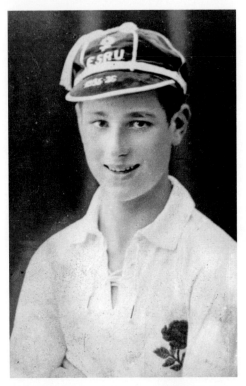

Thomas William Hutchinson, aged fourteen, 1936. Hutchinson played rugby for England against Wales on 21 March 1936 at Cardiff Arms Park, with a gate of 30,000. He played at right centre three-quarter in the Schoolboys International Match, being the only Durham County lad to figure in the English XV. He came from Rock Terrace, New Brancepeth, and played for Durham County Schoolboys. He was killed while serving with the Royal Artillery (d. 29.5.45). His name is listed on New Brancepeth War Memorial, together with that of his brother, Cyril.

Mr Donald (Danny) Webster, Vice-Principal of Bede College, 1933-61. Mr Webster had been a student at Bede College 'round about the period of the First World War (Bede College, by D.E. Webster, 1973). In 1991 new student accommodation was built (now a hostel) in Gilesgate near the Queen's Head public house, and was named Webster House. This photograph dates from c. 1936.

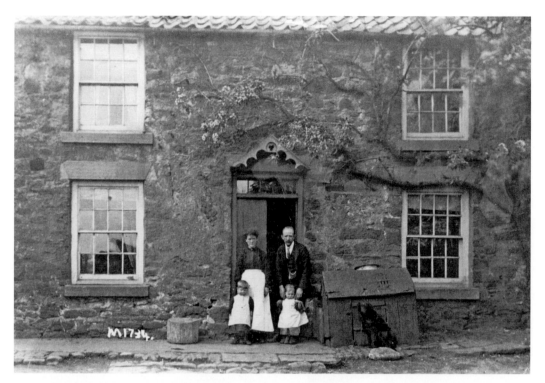

The Schofield family outside Pear Tree Cottage, Crook Hall Farm, *c.* 1909. The photograph shows Elizabeth and Henry, a coal-miner, with their children, William (left) and Jane (right).

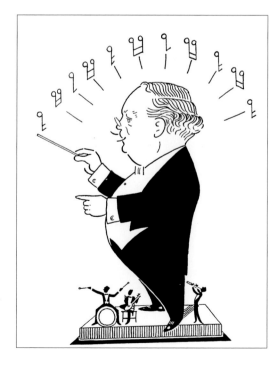

A lively caricature of Mr George Chandos Cradock, tenor soloist, Durham Cathedral, *c.* 1930. Appointed during the time of Dean Kitchin, he served also under Deans Henson and Welldon. Keen to involve townspeople in music, he founded the Durham Amateur Operatic Society (which is still flourishing), and the Durham Excelsior Society. For twenty years he was choirmaster at St Nicholas' Church, Durham. He died on 13 June 1934 and is buried in Elvet Hill churchyard.

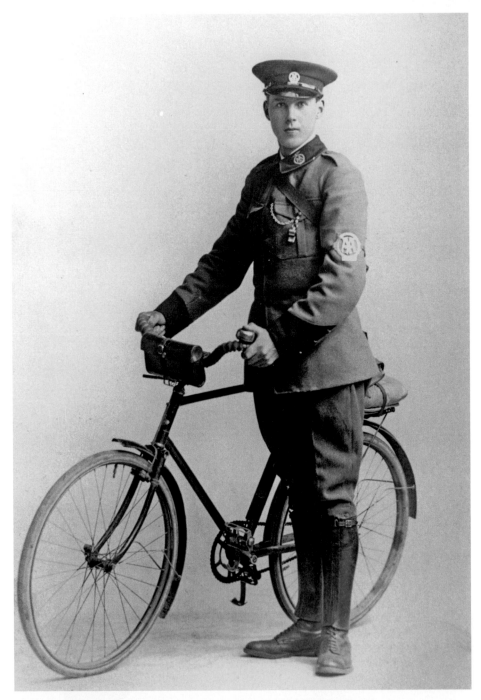

Percy Maughan, in a studio portrait by J. S. Adamson, City Studio, 69 Saddler Street, 1927. Maughan was an officer of the Automobile Association, established in 1905. The pouch on the cycle contained a first-aid kit and a booklet on how to use it.

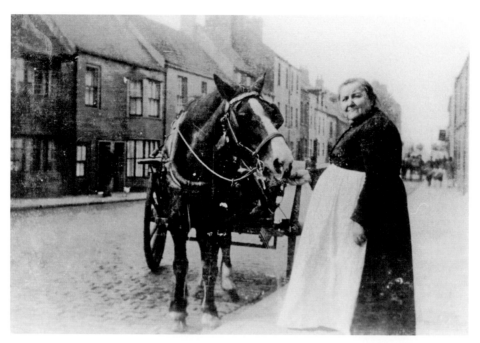

A local resident watches over a horse and cart belonging to a local milkman, near the Woodman Inn, Gilesgate, 1920s. The road behind her leads to 'The Chains', named after the chain-horses which once helped to pull horses and carts up the bank from Durham, An accident, caused when a chain-horse kicked a boy going to school was reported in the *Durham County Advertiser,* 24 September 1883.

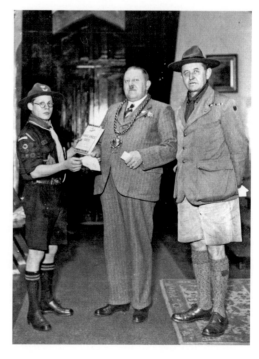

Scout presentation in the Town Hall, 22 November 1939. Left to right: Patrol Leader F. Keeling, the Mayor, Councillor S. Kipling, and the District Commissioner, Guy Stopford. The patrol leader is handing over a cheque for £5, raised by collecting waste paper and cardboard from local businesses in the city, for the Red Cross Fund. In recognition of the 5th Durham's work, Patrol Leader Keeling was presented with a scouting book by the District Commissioner.

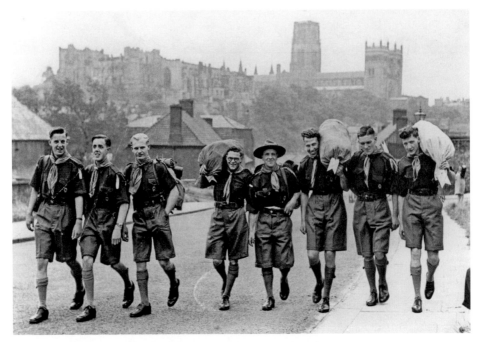

Flambard Rover Scouts leaving Durham along Framwellgate on their way to a camping holiday in Norway in 1946 to renew friendships which began at the Raby Jamboree in 1932. Left to right: Harry Bond, Tyrrel Clark, Billy Slater, Tom Telford, Bob Allan, Alf Howe, Jack Wallace and Gowin Wild.

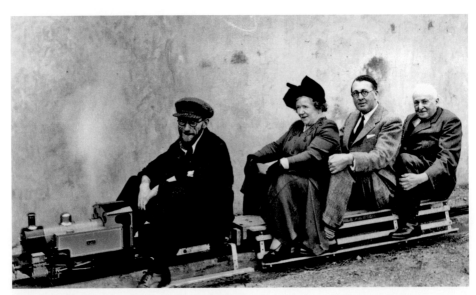

Billy Longstaff, Model Engineers Club, Gilesgate Community Association (Vane Tempest Hall), photographed during their third Spring Festival, 26 April 1952. Passengers, left to right, are Deputy Mayor Mrs H. Rushford, Lord Londonderry, and Mr W. McIntyre. One of Lord Londonderry's titles was the Lordship of Gilesgate, which, in December 1996, was offered for sale by auction in London, estimated price £7,000. In March 1997 the estimated price fell to £5,000.

SECTION THREE
The Built Environment

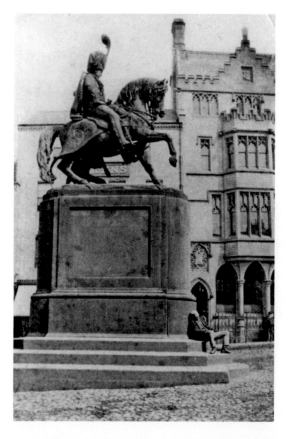

The Londonderry statue, Durham Market Place, c. 1875. The statue had been unveiled in 1861. This photograph, by R. Herbert, 3 Silver Street, was possibly taken on a Sunday morning, when all was quiet, as a local resident can be seen on the steps, sleeping off the night before. It is said that the horse has no tongue and that the sculptor committed suicide when this was pointed out to him. In fact, the horse has got a tongue and the designer, Raffaele Monti, died of liver disease in 1881, with his daughter in attendance (C.W Gibby, A Short History of Durham, 1975).

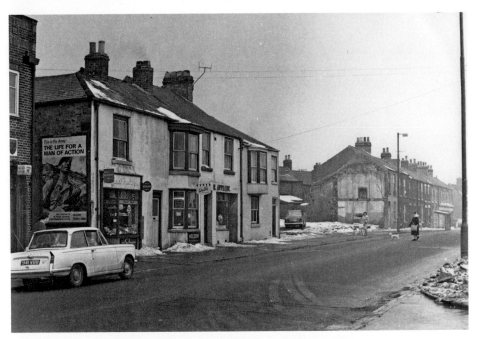

Sunderland Road, Gilesgate, 1960s. On the left is the Three Horse Shoes. Properties along this road were demolished in the 1960s to make way for a supermarket, car park and small retail shops. The corner of Churchill Avenue can be seen, bottom right. This scene was captured on camera by local photographer, Desmond Kelly (see p. 112 for his grandfather).

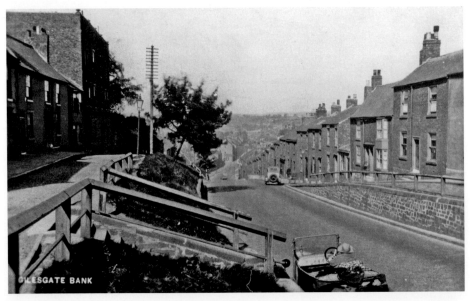

Looking down Gilesgate bank in the 1930s. On the left is Belvedere House, an early eighteenth-century building with an unusual flat roof. The building has been used for student accommodation ever since it became 'the Hostel' for third-year Bede men in 1895 (*The Bede* college magazine, March 1913).

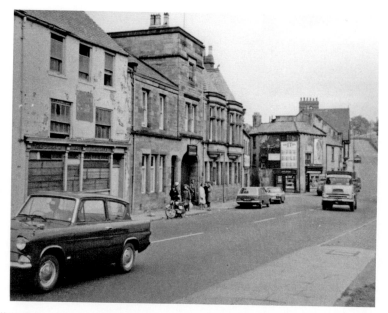

The Drill Hall, headquarters of the 8th battalion, Durham Light Infantry, at the bottom of Gilesgate bank. It was built by Jasper Kell & Sons, of North Road, and opened on 7 February 1902. To the right of the Drill Hall is the entrance to Station Lane and on the far left the Durham Ox public house. The photograph was taken shortly before these buildings were demolished in the mid-1960s.

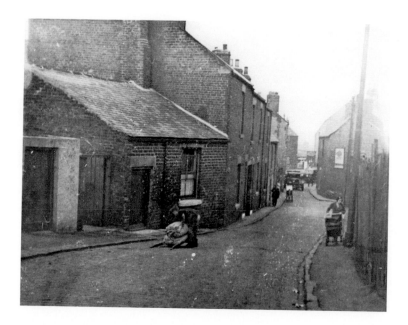

Looking down Station Lane towards the main road, 1930s. This area is now part of the Gilesgate roundabout. The young boy is loading bags of coal on to his sack-barrow and the young girl on the right is probably heading for Kipling's coal-yard. Michael Heaviside, holder of the Victoria Cross, was born here (see p. 111).

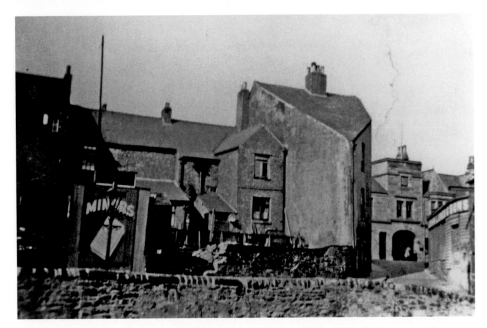

A view from Pelaw Leazes Lane (Bede Bank) looking towards the Drill Hall, *c.* 1937, showing, on the right, Lowes' Marble Works. Part of the lower lane, leading to Baths Bridge, still exists. The unusual shape of the large building, right of centre, is influenced by the shape of the corner where the lane meets Gilesgate.

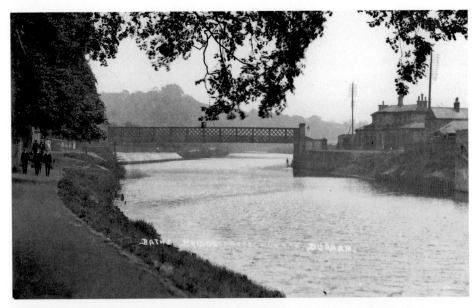

The second Baths Bridge, *c.* 1910, showing, on the right, the swimming baths of 1855, rebuilt and opened in 1932. The iron bridge, constructed by the Cleveland Bridge Company and erected in 1896, replaced an earlier bridge, known as Pelaw Leazes Bridge, of 1856 (Corporation of Durham minute book). The present concrete bridge was opened in 1962 by Councillor J. O. Luke. This photograph is by G. Fillingham.

Bailes' Corner, Saddler Street, *c.* 1860. The premises were those of the Bailes Brothers, Shoe and Bootmakers (cordwainers). The building was compulsorily purchased by the Local Board of Health (Local Board of Health Minute Book, May 1864) for £ 1,250, to make way for road improvements. It was removed in June 1864. For many years this was the stand for the town crier and bellman, Ralph Thwaites. Ralph succeeded Hutch Alderson, alias 'The Bishop of Butterby' (see p. 24).

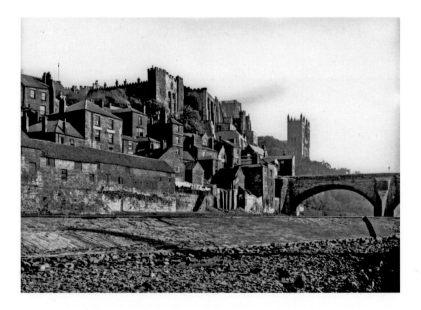

The Castle and Cathedral from Millburngate Waterside, 1890s. The photograph by F. W. Morgan shows the weir dam which led the water to Martin's Flour mill. The lower buildings on the left are in Fowler's Yard, named after Fowler the grocer of Claypath; the firm had its stables and warehouses there.

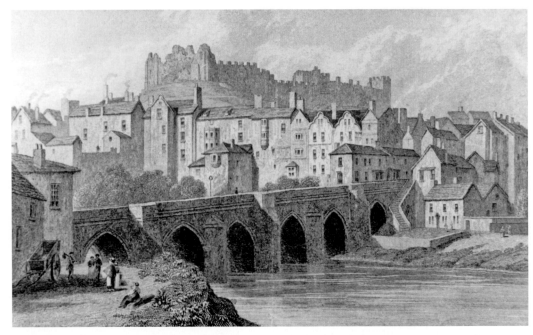

Elvet Bridge showing the Castle keep in ruins, drawn by W. Westall, *c.* 1829 (see p. 22). To the right of the bridge are the steps leading down over the entrance to the Old House of Correction, which was closed shortly after the new prison in Old Elvet opened in 1819.

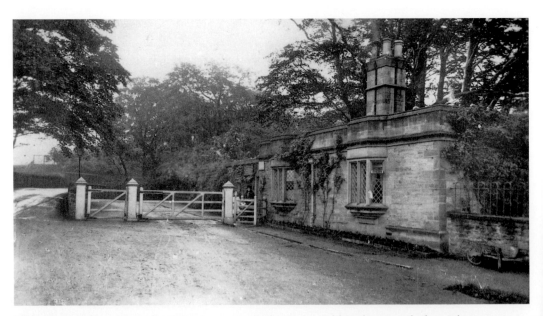

White Gates Cottage, Quarryheads Lane, *c.* 1900. Built 1820-30, although not marked on John Wood's map of Durham City of 1820, there is no other cottage in this style in the city. It had clearly become necessary to have a gate-keeper to assist horsemen and carriages going to and from Prebends Bridge (see opposite) and possibly to keep out trespassers. For the best part of the last century members of the Jopling family have occupied the position of gate-keeper.

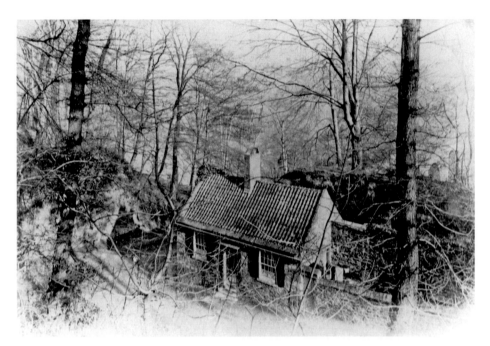

Prebends Bridge Cottage, also known as Bett's Cottage (from the name of a former inhabitant), *c.* 1895. The cottage is on the path leading down to Prebends Bridge, which can be seen beyond it on the right. This photograph is by F. W. Morgan.

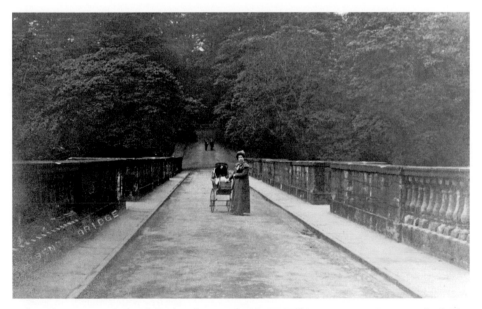

Lady with a pram on Prebends Bridge photographed by W. Wilkinson, *c.* 1900. In 1574 a footbridge had been built 150 yd upstream; it is marked on Speed's map of 1611. This was swept away in the Great Flood of 1771 and Prebends Bridge was built to replace it. The cost, £4,316, was borne by the Prebends (or canons) of the Cathedral, which explains the name. It was designed by George Nicholson, architect to the Dean and Chapter, and was opened to the public on 11 April 1778.

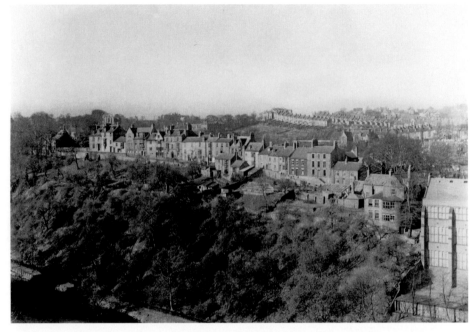

An unusual view of South Street, once the main north-south road through the county, from the roof of the Castle, c. 1940. On the right is the former Johnston School (see p. 63). In 1799 Ralph White bequeathed £10 to St Margaret's Church, the interest from which was to be given yearly to the poor of South Street.

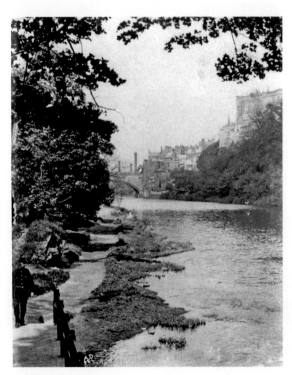

The tow-path leading from South Street Mill towards Framwellgate Bridge in the distance, 1890s. The chimneys beyond belong to Henderson's carpet factory. A city policeman is patrolling this beat.

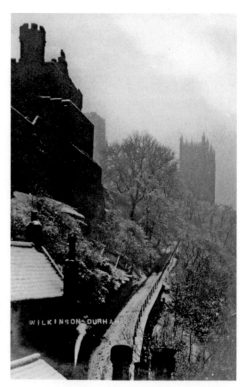

A winter scene from the Silver Street side of Framwellgate Bridge looking up towards the Broken Walls footpath, *c.* 1900. In February 1871 a portion of what was believed to be the Castle collapsed, about 30 yd up from the bridge. It turned out to be a rectangular tower, 16 ft x 21 ft and 44 ft high, built in the ramparts as a form of buttress.

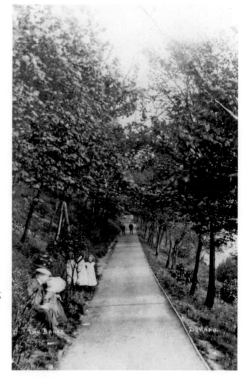

The tow-path below the steps at the bottom of Silver Street, *c.* 1906. In 1875-6 the Revd Canon Henry Baker Tristram of The College, supervised extensive improvements of the Durham Banks, introducing new walks, providing seats and planting 6,000 trees, including among them 3,000 Scotch firs, 100 oaks, 100 elms and 250 palm trees (a species of willow), as well as many shrubs and flowers. This photograph was taken by George Fillingham.

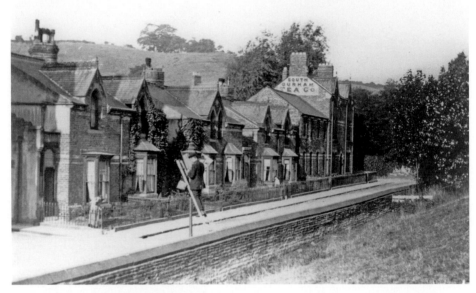

A lamplighter at work in Waddington Street (on the west side of Durham County Hospital), *c.* 1911. This street is named after Dean George Waddington (1840-69) who was a prime mover in the founding of the hospital in 1849-50. The building on the far right belonged to the South Durham Tea Company. It had previously been Ainsley's Printing Works and Mustard Mill.

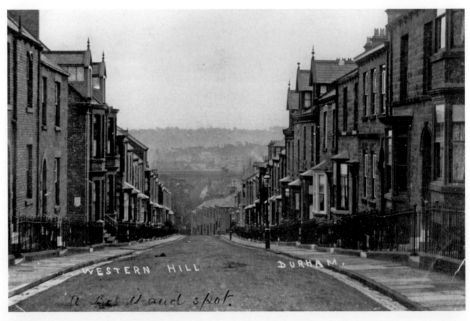

Looking down Western Hill, with the railway viaduct in the distance, *c.* 1910. This is one of the few city streets that has never altered. Although the street gives the appearance of having been built in one go, various plots were bought and built on at different stages between the early 1850s and the late 1860s. This accounts for the variation in the styles of houses visible in this photograph by G. Fillingham.

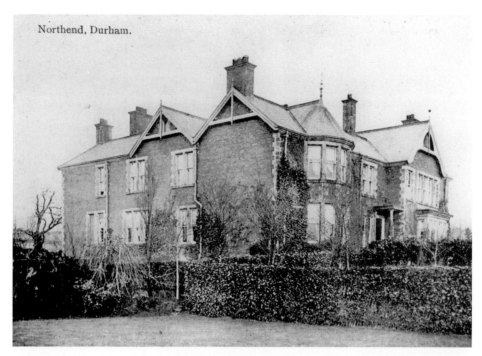

Northend, Durham.

North End House, the residence of John Francis Bell, JP, *c.* 1900. The building is now used by the NHS. Bell came to Durham in about 1876 and, with Mr John Adamson, carried on a corn business, Bell & Adamson, in North Road.

Newton Wynne, South End, Durham, the residence of Captain Newton Wynne Apperley, JP, *c.* 1900. At one time, in the 1850s, it was the Shepherd's Inn. The road to the right now leads to the Oriental Museum.

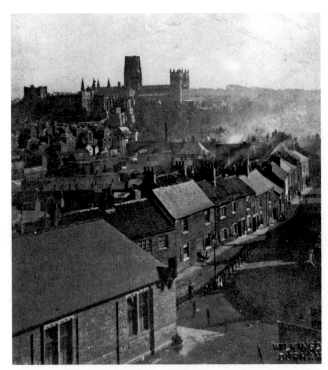

Looking down Framwellgate from the main railway line, *c.* 1900. On the left is St Cuthbert's Mission Hall, the foundation stone of which was laid on 24 October 1898. Dedicated by Bishop Westcott, 7 February 1899, it was built at a cost of £700. Later it was bought by Brian Clouston and converted into his landscape architects' office, St Cuthbert's House. The central area is now occupied by Millburngate House.

The statue of Nelson on his plinth in Wharton Park, late 1940s. The old pavilion behind the statue was used as a Quaker meeting place between 1939 and 1940 at a weekly rent of 5s. In 1940 the park's committee gave notice for the Quakers to vacate the pavilion, presumably because of a hostile demonstration against pacifists at the outbreak of war. The park was created in the 1850s by William Lloyd Wharton of Dryburn Hall.

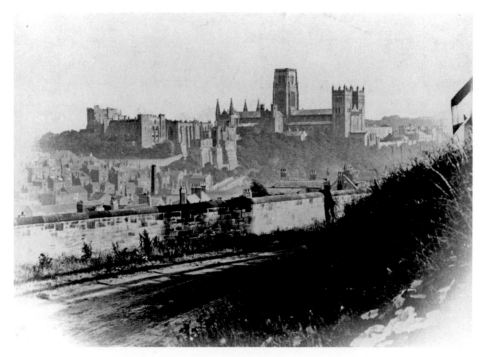

A Fred Morgan photograph of the city from the railway station, *c.* 1895. Morgan lived at 218 Gilesgate and had his studio in Saddler Street. Many of his views are among the finest surviving photographs of Victorian Duham. John Edis a Londoner then working at Darlington, came to Durham to work with Morgan in the 1890s. Morgan retired in the early 1900s.

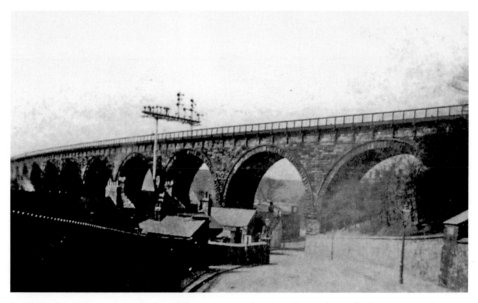

Looking down from the railway station, *c.* 1910, showing the viaduct which was opened in April 1857. The property on the left was demolished in the late 1960s for the new through road linking Millburngate Bridge to North Road. This photograph is by G. Fillingham.

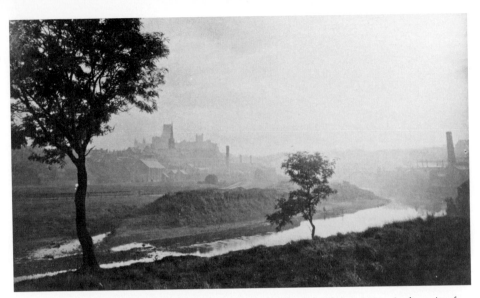

Durham from near Crook Hall, Sidegate, *c.* 1880. On the left of the picture is the exit of the mill-race from the Market Place Mill (Martin's Mill) which came out on The Sands. The field on the left was known as the carpet factory field and is now the site of the new swimming baths.

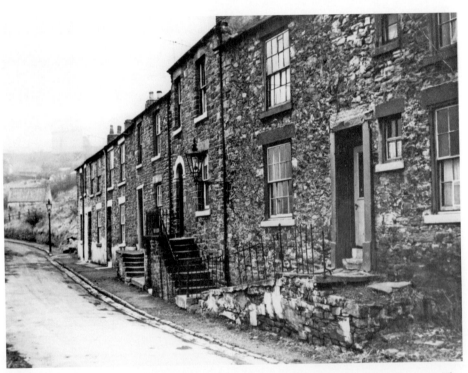

Cottages in Sidegate photographed shortly before they were demolished in the early 1960s. The house on the right was no. 23. In recent years Alan Wilson had his timber business to the rear of this street and it is now a car park.

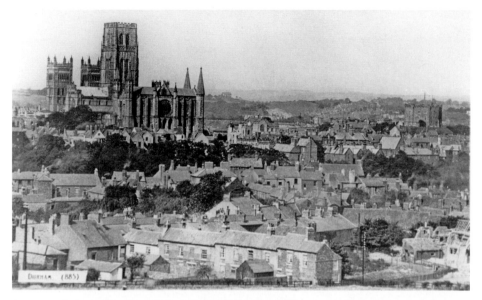

An unusual view of Durham Cathedral from Nine Tree Hill, *c.* 1913. At the bottom of the photograph, in the centre, are some cottages (now demolished) to the rear of the old Sun Inn, 34 Hallgarth Street.

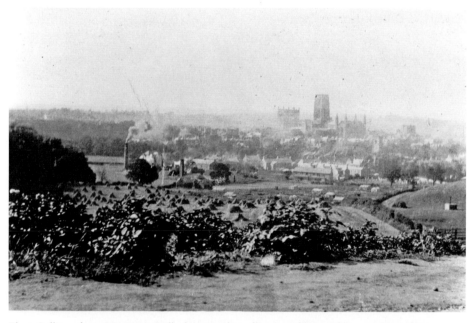

Elvet Colliery, from Mountjoy Hill, showing the colliery working with its smoking chimney, 1905. The hay-ricks in the field are a reminder of the slower pace of rural life. *Murray's Hand-Book of Durham & Northumberland* (1873) describes Durham's visible characteristic as being 'its dirt, for the smoke of the collieries, which envelops the county in every direction, blights vegetation, covers fields with black ashes, and hangs in a thick cloud overhead'. This photograph is by W. A. Bramwell.

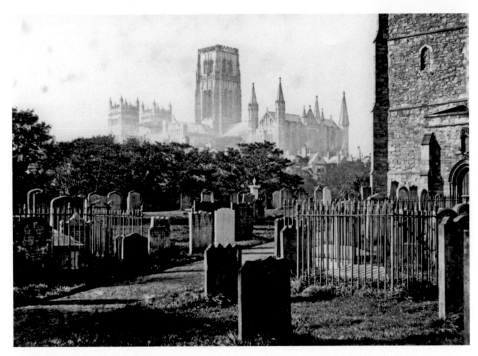

The Cathedral from St Oswald's churchyard, 1890s. This is one of Fred Morgan's finest views. The well known photographer and artist specialised in outdoor work and was awarded medals for his views of Durham.

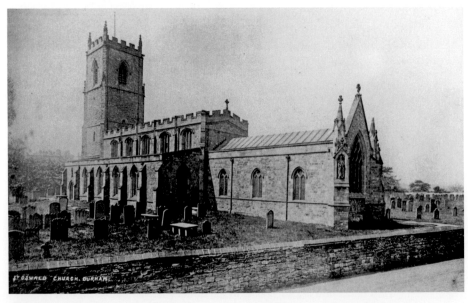

St Oswald's Church from Church Street, c. 1904. Iron railings were later added to the walls, but these were removed during the Second World War. In recent years the church has introduced a programme of grass-cutting and raking in the churchyard to create a controlled wildlife sanctuary and as a result many dormant wild flowers have returned.

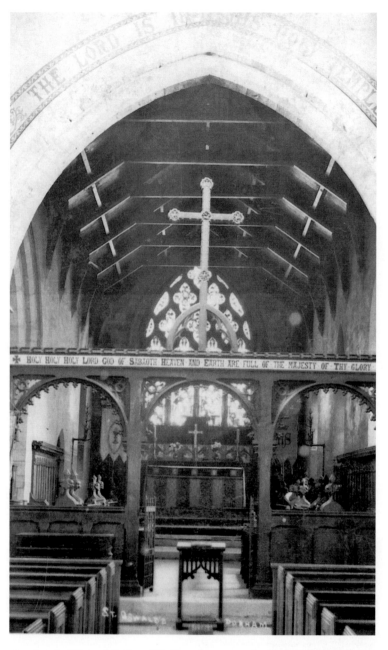

An interesting interior view of St Oswald's Church, *c.* 1910, by George Fillingham. The oak choir screen, presented by Archdeacon Thorp in 1834, survived an arson attack on the church on 7 March 1984.

Owengate, *c.* 1920. The name was first recorded in the fourteenth century. Later it was also called Queen Street. It was here in October 1946 that Jack Winter witnessed from his window in the almshouses, the ghost believed to be that of a University don who committed suicide by throwing himself down the black staircase within the castle. The ghost is reputed to appear at a certain time of the year, between the hours of midnight and 1 a.m., dressed in white, walking with his head down and his hands clasped before him (*Durham County Advertiser*).

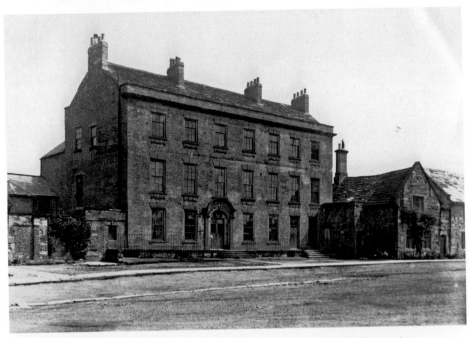

Bishop Cosin's Hall, Palace Green, *c.* 1910. A late seventeenth-century brick mansion, previously known as Archdeacon's Inn, it was a University hall of residence from 1851 to 1864. Members of staff of University College now have flats there. The right-hand door in the photograph was made into a window in the 1970s.

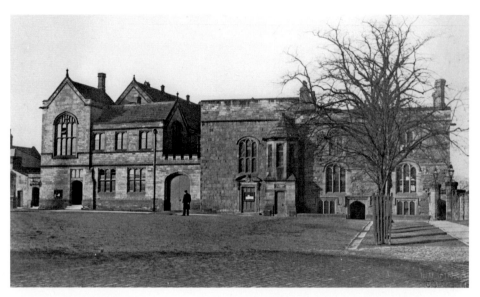

The west side of Palace Green, c. 1900. On the left is the University Library, dating from 1858, and on the right is the fifteenth-century exchequer and chancery. The central building is Bishop Cosin's Library, founded in 1669 and built by architect John Longstaffe. The Latin motto over the entrance means 'Not the least part of learning is familiarity with good books'. The turret door leads to the gallery, added in 1833-4 for students.

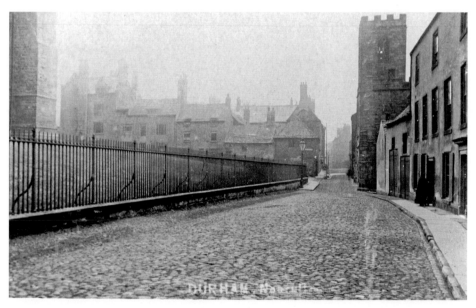

Looking along North Bailey towards St Mary-le-Bow Church, c. 1900. The old property on the right was pulled down to make way for St Chad's dining-hall in 1961. In the centre of the picture, at the foot of Dun Cow Lane, is the old Castle Inn. The Durham Freemasons' Lodge met there from 1768 to 1781 (Durham Masonic Centenary brochure, 1970). The inn seems to have continued as a 'beerhouse'. It became residential accommodation in 1870 and the well-known broadcaster, C.E.M. Joad, was born there on 12 August 1891.

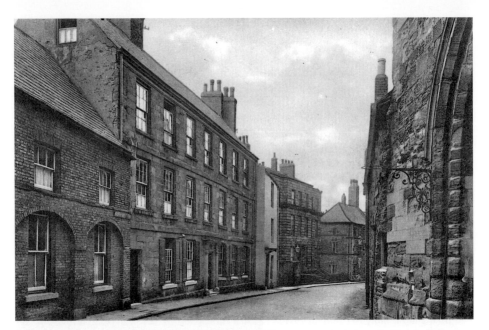

St Chad's College, South Bailey from outside The College gateway, *c.* 1920. St Chad's College was founded in 1904 as a hall of residence for the reception of students in theology or arts. It was constituted as a college in 1919.

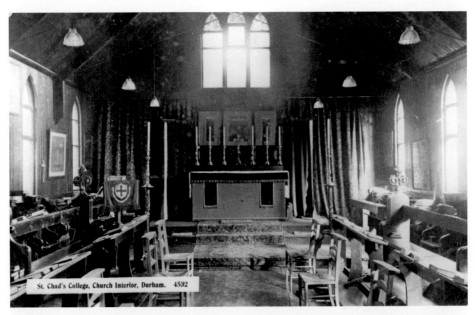

St. Chad's College, Church Interior, Durham. 4532

An interior view of St Chad's College Chapel, *c.* 1920. The chapel was erected by Mr Arthur Mann, joiner and contractor of Durham, in 1909 and dedicated on All Saints' Day that year by the Bishop of Jarrow. It was situated to the rear of the college and was constructed of wood. By 1928 it had become too small, so it was removed and replaced by a larger wooden structure which is still there today. The old chapel was re-used as a mission chapel (keeping the name St Chad's) in one of the local villages.

Chapel Passage, Old Elvet, 1940s. The building on the left was the Methodist Chapel, built behind the Royal County Hotel in 1808. After it was replaced by the present one in Old Elvet, which opened in 1903, the earlier chapel was used by the Salvation Army and later as a bakery, until it was demolished in the 1960s. The area is now part of the hotel car park.

Methodist schoolyard, New Elvet, which was behind the frontage opposite the Three Tuns Hotel, 1920s. The property in this area were pulled down in the 1960s to make way for University buildings.

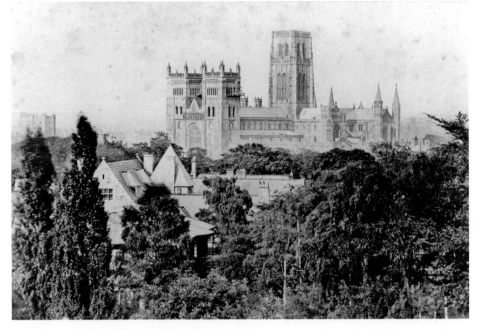

An early view of the Cathedral from the hill above Durham School by R. Herbert Photographer, 3 Silver Street, showing repairs being carried out to the south-west tower in the 1880s.

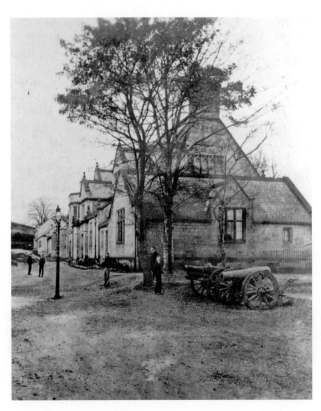

Durham School, showing the gymnasium and physics laboratory, c. 1933. The gymnasium and laboratory were designed by W. S. Hicks and built by Gradon & Sons of North Road in 1899. On 10 February 1900 they were opened by Bishop Westcott (see p. 9). The old guns on the right are no longer there.

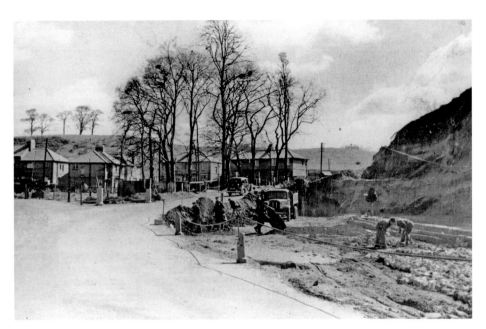

The Mountjoy-Quarryheads Lane road improvements, from Stockton Road, *c.* 1946. On the left, Nine Tree Hill can be seen.

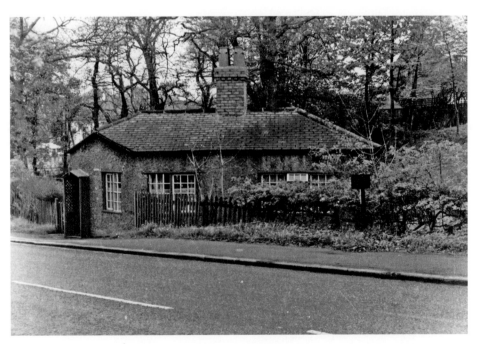

The old toll house, Potters Bank, *c.* 1960 (now pulled down). In 1873, at the monthly meeting of the Durham Board of Health, Councillor T. R. Richardson said 'it was time Durham took some steps to sweep away the whole of the seven toll gates that barred the free entrance to the city'. Potters Bank toll house (and adjacent land) was sold by auction to Mr John Fowler for £70 in 1875.

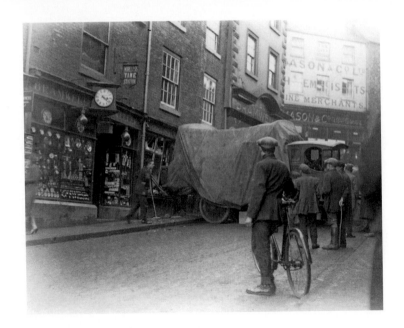

A van crash on Elvet Bridge, 29 January 1926. The vehicle was owned by Mr H. Leedale, haulage contractor of Chester-le-Street. While travelling towards Saddler Street from Elvet Bridge the vehicle moved backward on the brow of the hill, falling back into the window of Mrs Blackburn, hairdresser and tobacconist.

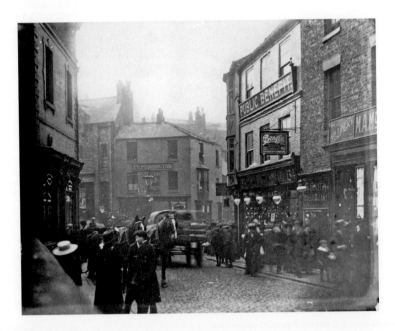

Looking towards North Road from the end of Framwellgate Bridge, 1920s. The property in the centre was knocked down and rebuilt several years ago. It had previously been 'In Time', a fancy gift shop. On the left is part of the old Colpitt's Criterion public house, which has been dismantled and replaced by retail premises.

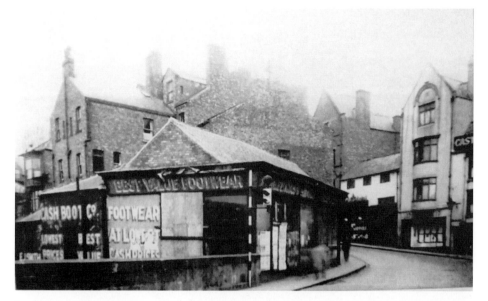

Looking towards the bottom of Silver Street, 1949. On the left is the Cash Boot Co., 22 Silver Street. Part of the Castle Hotel can be seen on the right and below the lamp is one of the entrances to Moatside Lane.

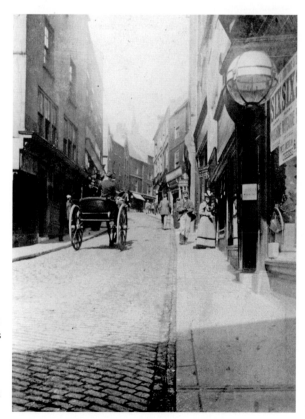

Looking up Silver Street, 1890s. According to *Lordship and the Urban Community*, by Margaret Bonney (1990), this is a misleading street name, as there is no surviving evidence to suggest that silversmiths ever lived or traded in this street in medieval times. This photograph was taken by F. W. Morgan.

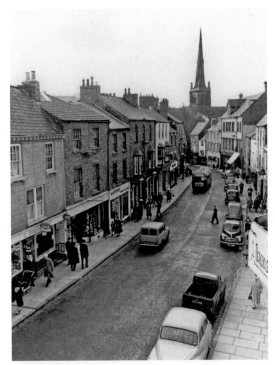

The lower end of Claypath looking towards St Nicholas' Church, *c.* 1964. The area beyond the white-washed frontage on the left was swept away for the road improvements, 1969-70. Bottom left is Dimambro's ice cream parlour, 90 Claypath.

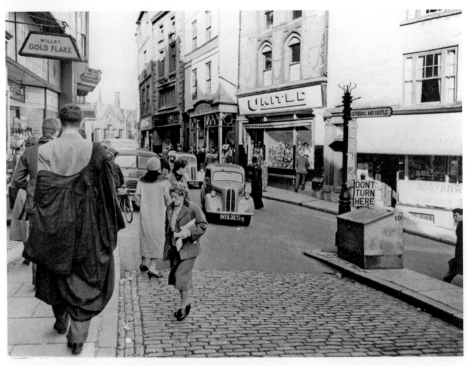

Looking towards the Market Place from Saddler Street, in the late 1950s, showing the junction with Elvet Bridge. Students wearing their gowns were a common sight in those days.

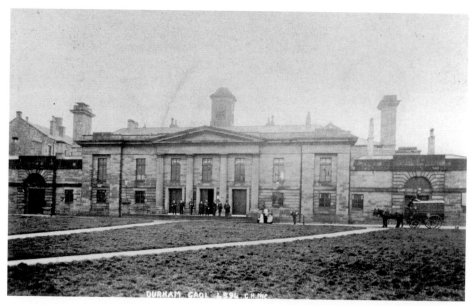

Durham Gaol and Assize Courts *c.* 1900. The Assize Courts opened on 14 August 1811 and were in use for a time. The foundation stone for the prison was laid on 31 July 1809 by Sir Henry Vane Tempest. The first two architects were dismissed. Ignatius Bonomi, aged twenty-seven, took over the design in 1814 and the prison was completed in 1819. The first prisoners were received from the old gaol (top of Saddler Street) and the House of Correction (see p. 38) on 4 August 1819 (Home Office reference leaflet, 'H.M. Prison, Durham', October 1968).

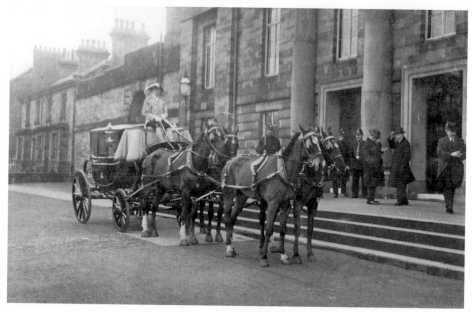

The judge's coach outside the Assize Court, Old Elvet, *c.* 1913. The judges had lodgings in Durham Castle. This had been agreed in 1837 when the Castle was handed over to the University. Until then it had been the residence of the Bishops, who afterwards made Auckland Castle their only home.

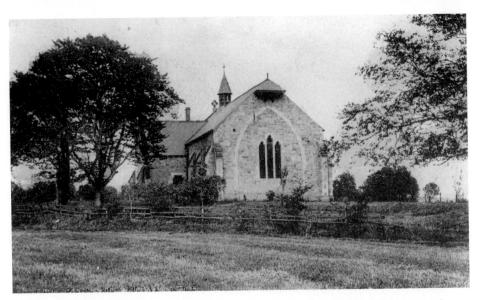

St John's Church, Nevilles Cross, originally a mission church connected with St. Margaret's, *c.* 1905. The foundation stone was laid on 17 September 1895 by Viscountess Boyne; the consecration, by Bishop Daniel Sandford, assistant Bishop of Durham, took place on 8 April 1896. It was designed by Plummer & Burrell, of Newcastle and Durham, at a contract cost of £1,000. Before the opening of the church services had been held in a little upper room in Mr Marshall's house, Prospect Terrace.

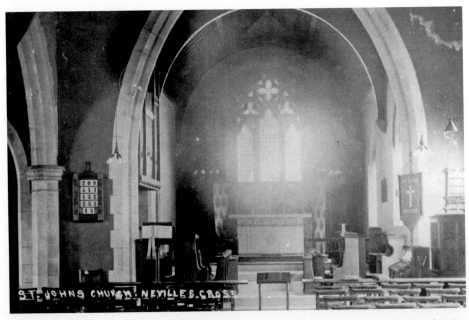

An interior view of St John's Church taken by George Fillingham, *c.* 1914, showing the electric light fittings which had been installed the year before. A chancel, vestry and organ chamber had been added in 1908, as a memorial to the Revd George S. Ellam, former curate, who was killed nearby in a motorcycle accident. (Ellam Avenue, being built at the time, was given his name.)

SECTION FOUR
Education

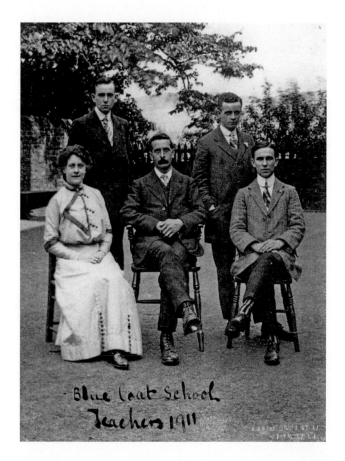

Teachers of Blue Coat School, 1911. Sitting on the left is Mrs Mary Fish (headmistress of the girls' school, 1876-1919), and centre is Mr Fred Howard (headmaster of the boys' school, 1900-30). This photograph was probably taken at the centenary of the school moving from the Market Place to its new site in Claypath (behind the shops of Blue Coat Buildings). The school moved to Newton Hall in 1965.

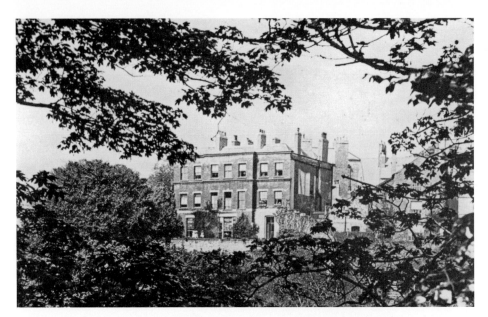

Durham High School for Girls, 3 South Bailey *c.* 1910. On 4 December 1883 a public meeting was held in Bishop Cosin's Library to discuss and promote the establishment of a high school for girls in Durham. The school was started in April 1884 at 33 Claypath and in 1886 it moved to the Bailey (now Haughton Hall, St John's College). In September 1912 the school was on the move again, this time to the town house of the late John Henderson (see below). Finally, a new purpose-built school was erected at Farewell Hall in January 1968. This photograph is by J. R. Edis.

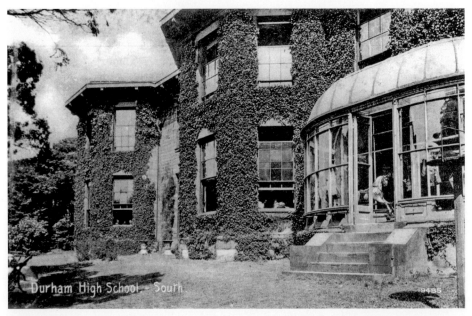

Durham High School for Girls, Leazes House, Claypath, *c.* 1920. Once the home of John Henderson (see p. 24), the house has now been turned back into a family home.

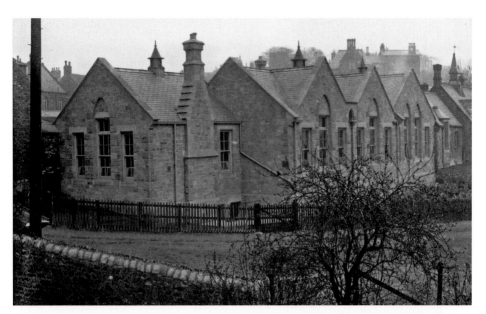

St Hild's Practising School, April 1911, one month before the girls moved into it from their rooms in St Hild's College. Built by John Shepherd, it was adjacent to the infant school building which had been there since 1864. In 1965 the school (by then mixed junior and infants) moved to new premises to the east of Mill Lane, Gilesgate Moor. Its old buildings were then taken over by the University of Durham.

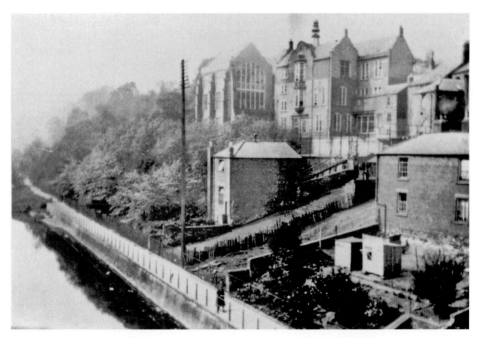

The Johnson School, South Street, from Framwellgate Bridge, c. 1928. It was opened on 23 June 1901, the extension on the left being added in 1909. The site is now occupied by 1970s town houses, which contrast with the more elegant, eighteenth-century properties further up South Street.

Infants from St Cuthbert's Roman Catholic School, Old Elvet, *c.* 1923. Second row, fourth from the right, is Nancy Harrington, while Millie Harrington is in the third row, second from the left. The school opened in Old Elvet overlooking The Racecourse, in 1847. It closed in 1961 and the building was converted into the University Catholic Chaplaincy in 1966 (J. M. Tweedy, *Popish Elvet*, 1981, Part 2).

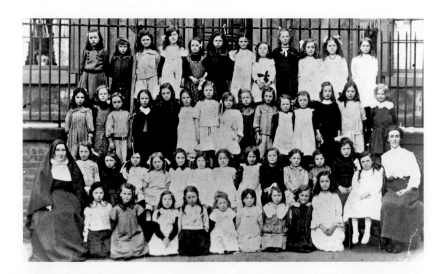

Juniors from St Godric's Roman Catholic School, Castle Chare, 1920s. On the left, in the front row, is Sister Theresa, who taught at the school when it opened in 1898. The new school was officially opened by the Mayor, Col. Rowlandson, on 13 October 1898. The architect was Mr C. Walker of Newcastle and the builder Mr F. Calddeugh of Durham. The cost of the site and building was around £5,000. In 1996 the school moved to a new purpose-built site at Newton Hall *(Durham County Advertiser)*.

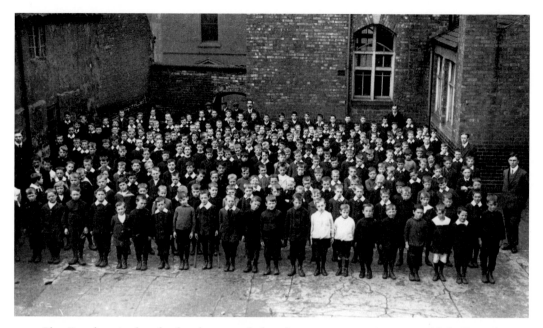

Blue Coat boys in the schoolyard, *c.* 1911, before the 1912-13 extensions were added. Claypath can be seen in the background. This photograph and the one below were probably taken as part of the centenary record by G. Fillingham. The number of boys in the school had been 'some 180' between 1887 and 1893 and it was increasing. The distinctive uniform which gave the school its name had been discontinued in 1850 *(Durham Bluecoat Schools, 1708-1958,* by R. Chadwick, 1958)

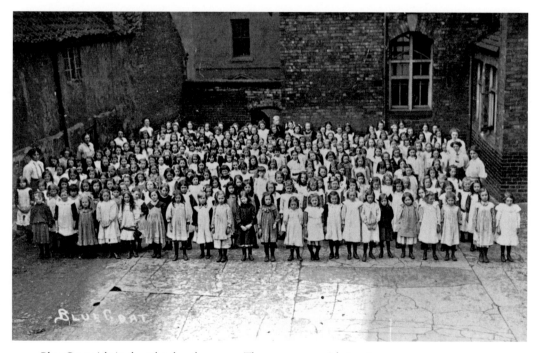

Blue Coat girls in the schoolyard, *c.* 1911. There were 113 girls in 1899.

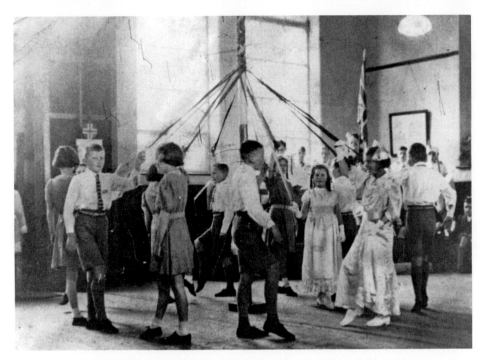

Practising for the May Day festival in the upper room, Blue Coat School, Claypath, *c.* 1941. This annual ceremony of crowning the May Queen was introduced in 1933 by headmaster Mr Percy Bramwell. It survived the move to Newton Hall but was discontinued in the early 1980s.

City of Durham School for Girls and Little Boys, 2 Ravensworth Terrace, Gilesgate, *c.* 1906. One of a number of private schools, it was already in existence in 1846 at 4 Leazes Place, under Mrs Ann Gibson. Obviously doing well, it was extended to include 5 Leazes Place in 1854. Miss S. Notman took over in 1882, moving to Ravensworth Terrace in 1887. It continued under Miss Gordon in 1902 and finally closed between 1915 and 1921. Such dame-schools ceased to be needed with the improvement of state schools and the increase in numbers of trained teachers.

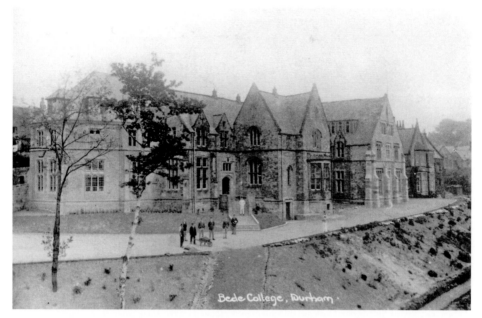

Bede College, one of the first diocesan colleges to provide qualified teachers for church schools, *c.* 1900. Students moved there from a house in Framwellgate. In 1847. Its title then, 'The Durham Diocesan Training School for the Education of School-masters', was changed to the simpler 'Bede College' in 1886, at Bishop Lightfoot's suggestion.

Durham from the grounds of Bede College, *c.* 1950. The First World War Memorial lists eighty-six names of those who were killed in the war, and was designed by W. A. Kellett of Bishop Auckland. It was dedicated on 26 May 1922 by the Bishop of Durham and unveiled by Lt Col. Ritson *(Durham County Advertiser)*. The present college gardens were designed by Professor Brian Hackett, Professor of Landscape Architecture at Newcastle University.

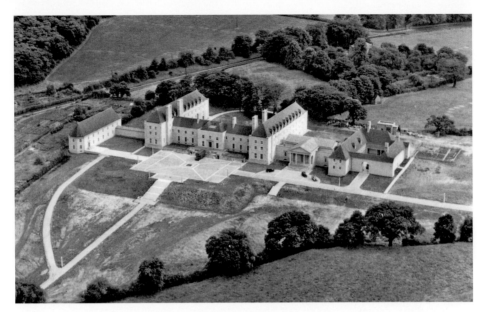

An aerial view of St Mary's College, designed by Vincent Harris, soon after its completion in 1952. The foundation stone was laid by Princess Elizabeth (later the Queen) in October 1947 (see p. 109). Women students were first admitted to the University in 1895, but accommodation was not provided for them until 1899. Eventually their Women's Hostel moved to one of the houses in The College and in 1919 it became St Mary's College.

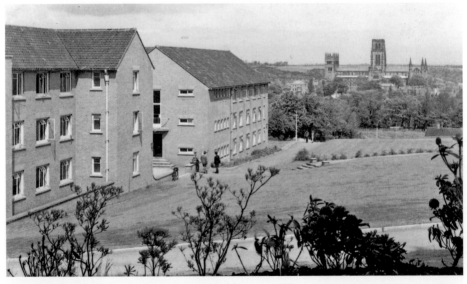

Grey College, Fountains Field, South Road, shortly after completion by architect T. Worthington, c. 1967. During the construction the builders had to surmount difficulties with underground water. Then, in March 1959, a fire damaged the roof and top floor. Nevertheless, the first students were able to arrive in October of that year. Its name recalls Charles, 2nd Earl Grey, for it was during his time as Prime Minister that Parliament sanctioned the foundation of the University of Durham in 1832.

SECTION FIVE
Leisure & Sport

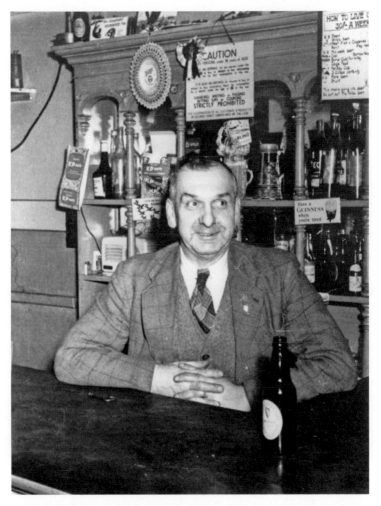

Mr Alexander Seed, landlord of the Burton House, 51 Crossgate, 1950s.

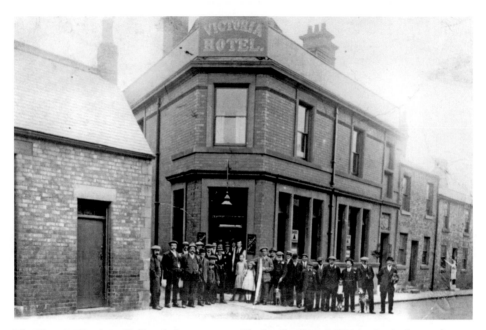

The Victoria Hotel, 86 Hallgarth Street, 1920s. The landlord Mr J. W. Marriot is the gentleman in shirt sleeves. This is now one of the few public houses in the city to retain its original character. This is a rare street scene by Ernest Photographers, 21 Silver Street, better known for their studio portraits.

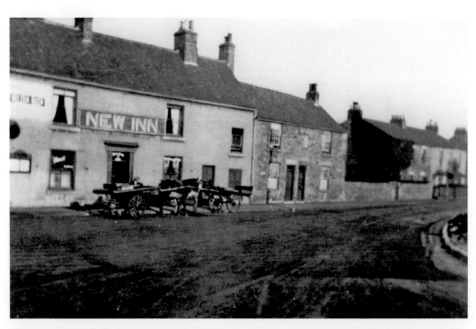

The New Inn at the head of Church Street, c. 1926, before the mock Tudor facing was added. It is one of the oldest surviving inns in the city, marked on John Wood's 1820 map. The road on the right is Stockton Road leading to Mountjoy. The two cottages on the right were demolished in the 1960s to make way for the pub car park.

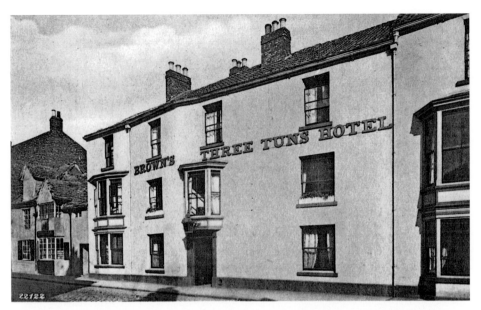

The Three Tuns Hotel, New Elvet, *c.* 1907. This was marked as an old coaching-inn on John Wood's 1820 map. According to a 'List of Inhabitants . . . and Coaching Houses, 1827', the Wellington coach called there on its way to London or Edinburgh. The Three Tuns was famous for Mrs Brown's cherry brandy, with which the hostess greeted each traveller. The site of the Cock Inn (on the left) is now the entrance to the car park.

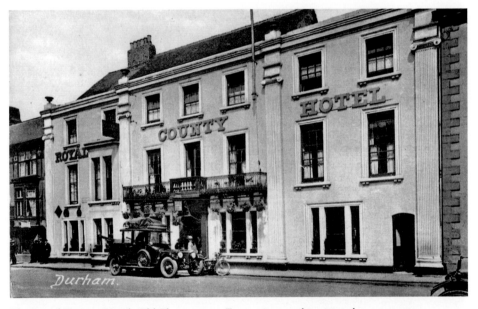

The Royal County Hotel, Old Elvet, 1920s. From 1815 to the 1860s there were two Waterloo Hotels alongside each other. The one known as Thwaite's (see p. 104), demolished *c.* 1970-71, was originally the Green Dragon Inn; next door was Ward's Waterloo, now the Royal County Hotel.

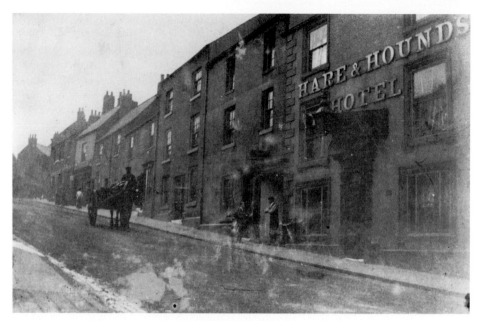

The Hare & Hounds Hotel, 54 New Elvet *c.* 1905. The site is now a pleasant green open space between Dunelm House and Elvet Riverside. In about 1961, when the hotel was being demolished, a seam of coal was discovered in the cellar.

The push-ha' penny team outside the Lambton Arms public house, 101 Framwellgate, *c.* 1928. Left to right: Billy Lishman, Billy Tate, Harry Wilby, Walter Wilby, Charlie Livett and Norman Johnson.

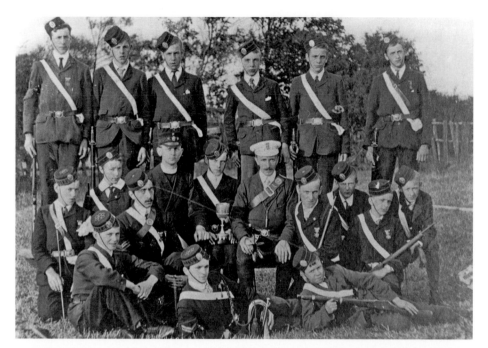

St Margaret's Church Lads' Brigade, 1905. In the middle row are Assistant Battalion Chaplain, Canon Hughes and Capt. Theo E. Bayldon, Company Commander. The brigade was started in 1903 by Canon C.J. Thurlow, when he was a young curate at St Margaret's, and he was one of the first officers; Canon Thurlow was later rector and Captain of the Company. In March 1983, when the rector, Stephen Davies disbanded the brigade, the *Durham County Advertiser* reported him as saying that 'marching with trumpets and drilling were not appropriate in a postwar period'.

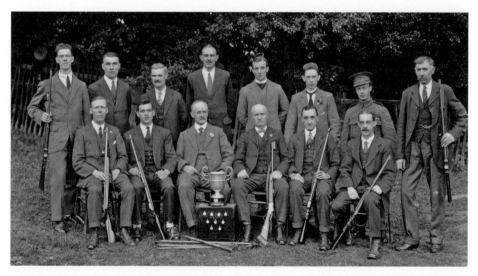

Durham County Rifle Association, Summer League Championship, 1922. Back row, left to right:' G.F.C. Smith, T.H, Pollard, W. Potter, Capt. E. Moore, the Revd M. Wells, H. Rutherford, Sgt Walton and J. Benson. Front row; P.N. Chisholm, E Geden, A.E. Thwaites, J.F. Wallace, W.G. Oliver and W.E. Everard.

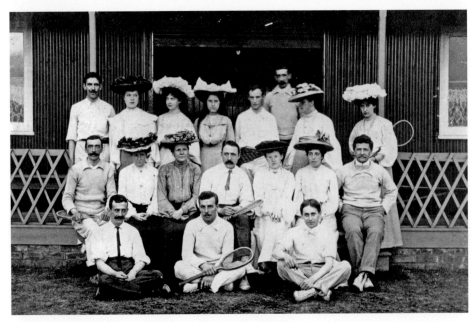

Durham City Tennis Club, *c.* 1905. Founded in 1888 as part of the Durham City Cricket Club, the tennis club had five grass courts situated at the east end of The Racecourse. The pavilion was purchased in 1905 for £23 10s, and was officially opened by the Mayor of Durham, George Henderson Proctor, on 24 May 1905. After the ceremony tea was served in the pavilion by Miss Battensby.

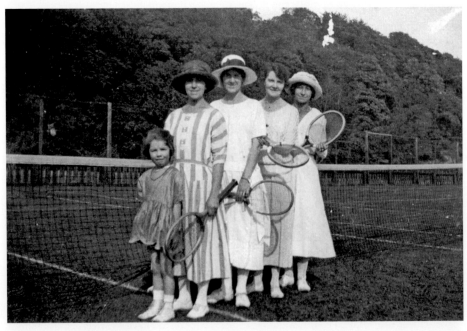

Durham City Tennis Club members on the courts, 1923, Pelaw Wood is in the background. On the left is Rita Gibson of Atherton Street, the ball-girl.

Durham City (Private) Bowling Club, 1890s. The club was founded in about 1888-9. In October 1974 a fire destroyed the men's section of the club, destroying all the club records going back to 1888. The following names appear on the reverse of the original: Seymour Nelson, Mr Chapelow, Messrs Hiller (senior and junior), Mr Bell, Mr Hinchly, Mr Dixon, Charlie Earle, Mr Thwaites, Mr Caldcleugh, Mr Herron and Mr Gibson (builder).

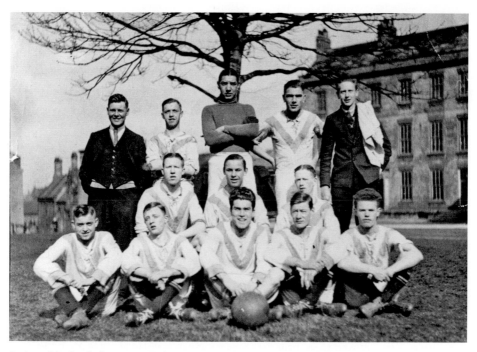

St Oswald's football team on Palace Green early 1930s. James Anderson is pictured behind the ball in the front row, Cosin's Hall is on the right and Owengate on the left (see p. 50).

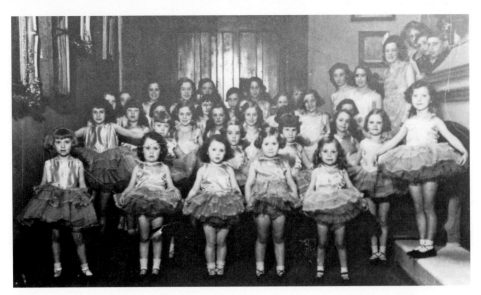

Miss Ainsley's dancing class in the Town Hall foyer, 4 May 1936. The occasion was the annual dancing display by juniors and seniors, when the girls performed in front of an audience of 400. Among the names on the reverse of the original are: Rita Jopling, Noreen Elsdon, Lily Rundall, Sylvia Forbes, Dorothy Argument, Muriel Rowell, Nancy Walker and Ruth and Lily Heywood.

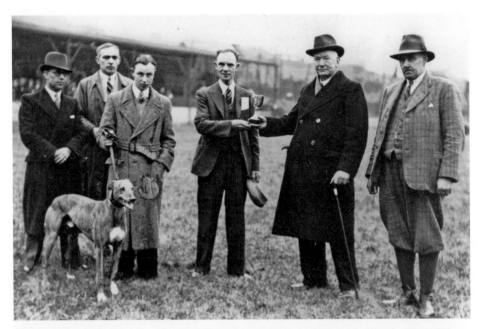

Holiday Park Greyhound Racing Track, Sidegate, March 1940. This was the occasion of the fifty-second race won at Holiday Park by *On the Run*, which belonged to Septimus Patterson. Mr Patterson is seen being presented with a cup by Alderman T.W Holiday. Left to right: -?-, J. Kingston, Arthur Patterson, Septimus Patterson, Alderman T. W Holiday and Mr Fortune. Holiday Park was opened in August 1923 as a football ground and became a greyhound stadium in about 1938. It closed in the mid-1960s.

SECTION SIX
Working Life

*Mr Billy Hudson of Tenter Terrace, at his hardware stall in Durham Indoor Market, 1960s.
After war-service in the Second World War he joined his father on the market stall. In later
years he was also manager at Wood's saleroom, Claypath.*

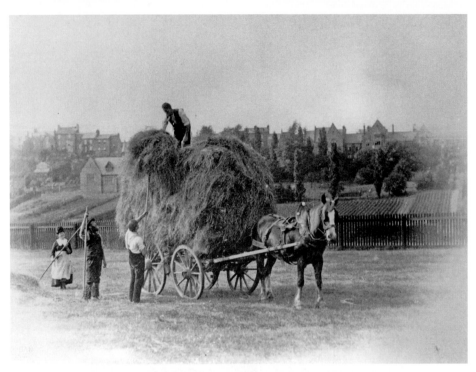

Haytime on The Racecourse, c. 1895. This fine study by Fred Morgan serves as a reminder of the rural nature of the city. To the left can be seen the old Bede Model School (now Carter House) which closed in 1933. On the right is Bede College.

A cart from Mawson & Swan, Yeast Merchants, 1890s. Their business premises were situated at the rear of 115 Gilesgate. Part of the site is now used as offices.

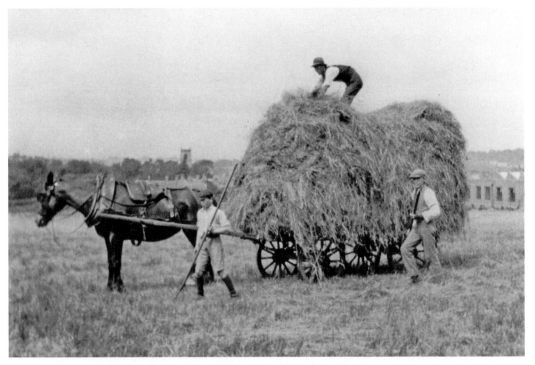

Harvest time at Mountjoy Farm, 1930s. On the right are the old University science laboratories, and on the left is the tower of St Oswald's Church. The two men standing beside the hay cart are Randy Stevenson (left) and George Mug (right).

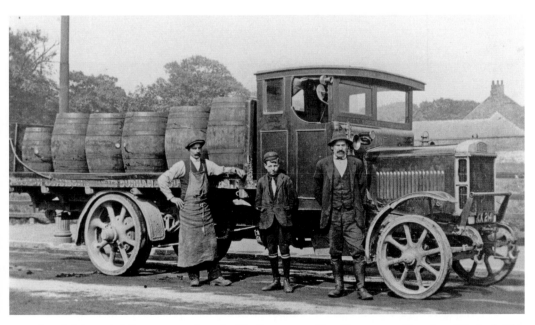

Joseph Johnson's delivery wagon, from the City Brewery, 74 New Elvet, 1920s. Note the solid wheels. This firm was once the largest wine and spirit merchant in the city. Occasionally its bottles turn up for sale.

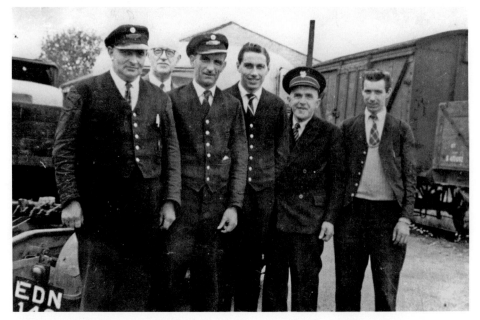

Staff at the goods station, Station Lane, Gilesgate, *c.* 1961. Left to right: Ray Davison, Mr Nuttall, Tommy Danby, Douglas Beeby, Mr Gibson, Dennis ? The A690 to the Carville interchange now runs past the goods station for much of its length along the line of the original railway embankment.

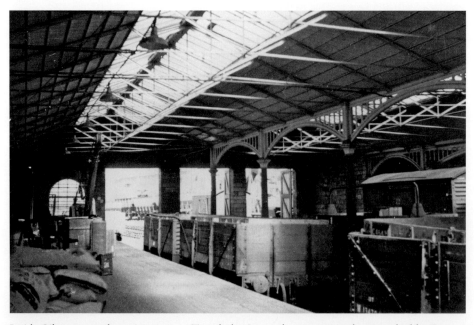

Inside Gilesgate goods station, (now a Travelodge Inn and restaurant), photographed by Dr C.W. Gibby, *c.* 1960. Designed by G.T. Andrews of York, it was the first station to reach the heart of the city, in June 1844. It became the goods station in 1857 and was closed in November 1966.

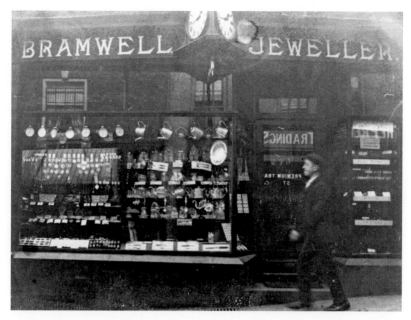

Bramwell's, jeweller, watchmaker and optician, 24 Elvet Bridge, 1905. One of the oldest established family businesses left in the city. They opened the Durham shop around 1903. The shop had previously belonged to T. Brewster, watchmaker. The shop entrance is now to the left of the window. Mr W.A. Bramwell was later joined by his brother who became a partner. Later his brother opened an optician's shop at 26 Elvet Bridge, before moving across the road to 18 Elvet Bridge (see p. 82).

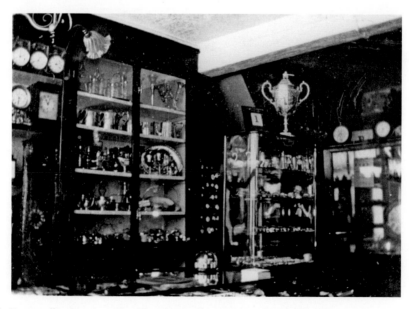

Inside Bramwell's shop, c. 1905. The shop still retains its character as a family-run business. Mr Bramwell was also a well-known local photographer who captured many interesting images of Durham.

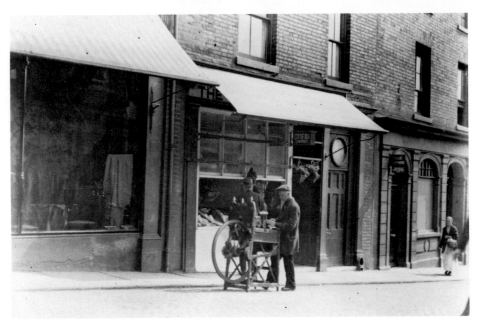

A lost trade, Mr James Watson, knife-grinder at work, outside the City Fish & Game Company, 17 Elvet Bridge, May 1924. This shop had previously been Samuel Hume's jewellery and watch- and clockmakers and was recently part of Pattison's the upholsterers. The property on the right was the telegraph office.

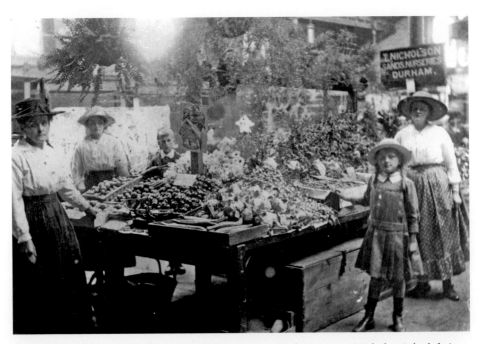

Nicholson's fruit and vegetable stall, Durham's Indoor Market c. 1912. Nicholson's had their market gardens near The Sands. The young boy in the centre behind the stall is Jack Raybole. The New Markets first opened in December 1852, when most of the stallholders were butchers.

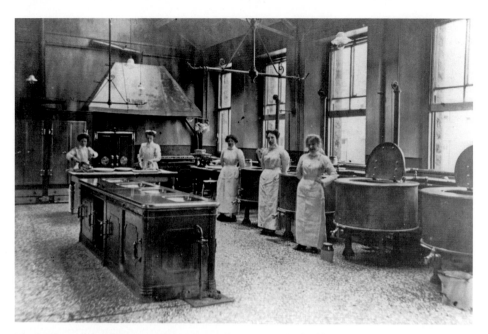

The kitchen of the Miners' Hall, North Road, *c.* 1907. The building was constructed in 1874-5 for the Durham Miners' Association. A new hall was built on Red Hills Lane, opening on 23 October 1915. After years of neglect and alterations to the front of the old hall, an attempt has been made in recent years to restore the former frontage.

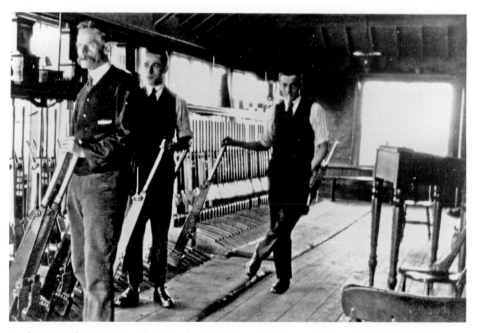

Durham North signal-box, showing the manual controls, 1920s. These were replaced by unmanned automatic controls in the early 1970s.

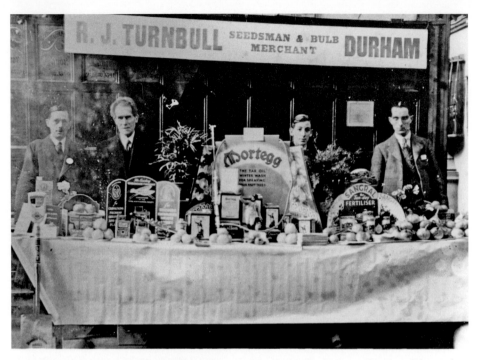

Turnbull's seedsman and bulb merchant's from 52 North Road taking part in one of the trade fairs held in the Town Hall *c.* 1935. On the left is T. W. Salkeld of 173 Gilesgate.

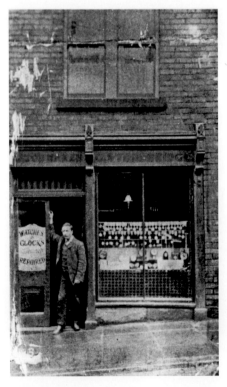

G. Stonebridge, watchmaker, 34½ Claypath, *c.* 1913. This photograph, damaged over the years, is believed to be the only one of these premises, which were demolished in the 1960s.

The *Durham County Advertiser* office, 64 Saddler Street 1930s. The building was originally built as a bank for the North Eastern Banking Co., 1897-8. The safes still survive in the basement. The *Durham County Advertiser* was first issued in September 1814. On the left is the Shakespeare public house and on the right is the Unemployment Office, formerly the old General Post Office.

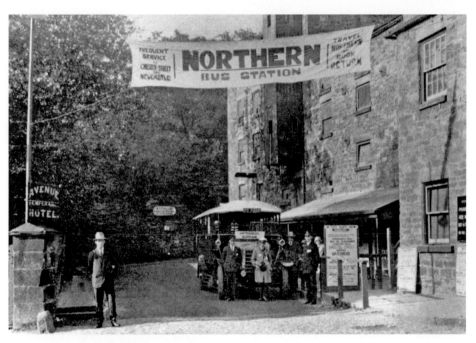

The Northern Bus Station, North Road, *c.* 1926, in the yard of the City Mill, a flour mill belonging to R.V. Hills. This building was pulled down shortly after the photograph was taken to make way for a new purpose-built station. Built in 1927-8, it had several outlets into North Road and an ornate cast-iron canopy. On the left is the entrance road to the former Avenue Temperance Hotel, now Avenue House, used as a private day nursery.

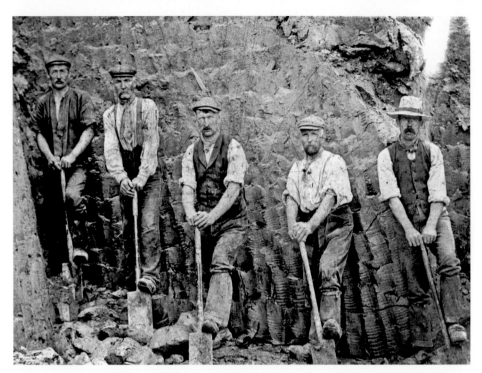

Brickyard workers, possibly from the Framwellgate Moor Brick & Tile Co., 1890s. Edward Mahan is second from the left. This unusual photograph was taken in the claypit.

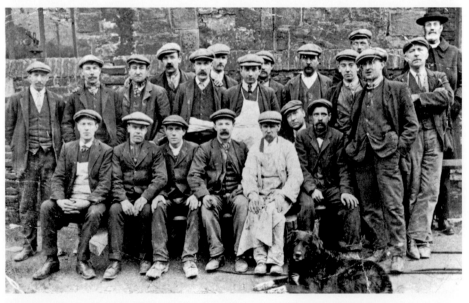

Workers from Gradon's at Blue Coat School, Claypath, c. 1912. In the back row on the right is the Revd Westley Bothamley, vicar of St Nicholas' Church. The picture was taken during the extensions of 1912-13. During this time the children met in the packing-room of the old carpet factory at Freeman's Place.

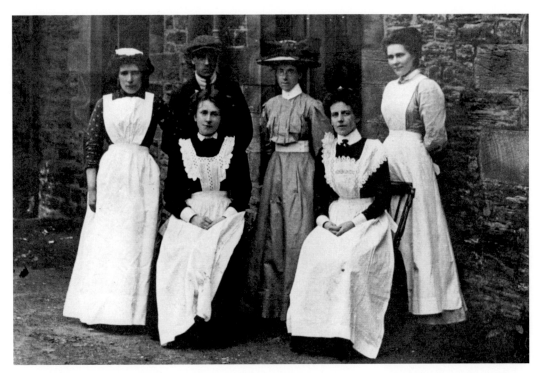

Staff from the Deanery, The College (see p. 17), *c.* 1906. In the front row on the left is Annie Carter and Jane Norman is standing on the right. Up until the late 1930s it was usual for large households to have a number of domestic staff.

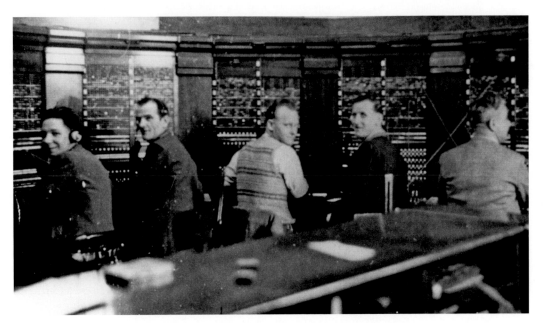

Durham City switchboard operators, *c.* 1947, at work in the telegraph office on the top floor of the old post office in Claypath. Left: to right: J.G. Dixon, -?- , R. Coates, H. Hall and R. Davison.

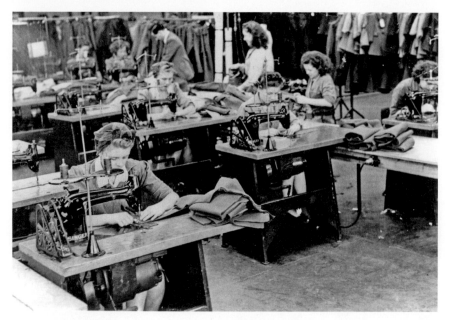

Bickley's Clothing Factory, Dragonville, *c.* 1947. On the left is Hilda Chilton of Carville where the business was first started in an old chapel. The factory closed in the mid 1980s.

Girls from Wood & Watson's 'Pop' factory, Gilesgate, *c.* 1960. Back row, left: to right: Maureen Wood, Maureen Blair, Joan Burns, -?-, Rachel Vicarage and Anne Wilson. Middle row: Hilda Marsey, Jean Row and Anne Wilson. Front row: Mavis McCabe, Susan Skelly and Faith Wilson. In May 1997, after just over 100 years, the company was sold to Clarks of Newcastle and the factory site now is a housing development.

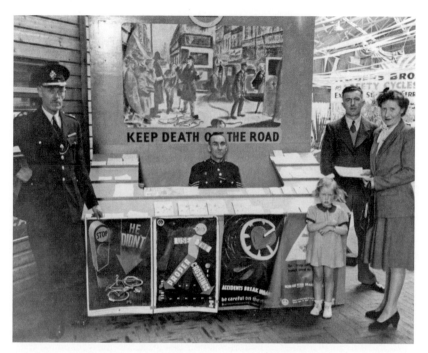

Durham County Constabulary road safety stand, *c.* 1947. On the left is superintendent of traffic, Hugh McFadden and seated is Sgt James Jackson, a former Johnston School pupil who rose through the ranks to become Chief Inspector.

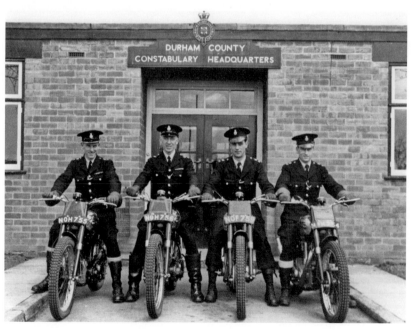

Durham County Constabulary motor bike team, *c.* 1949. Left to right: Gordon Stonehouse, Jimmy Bailes, Alan Vickers and John Bell.

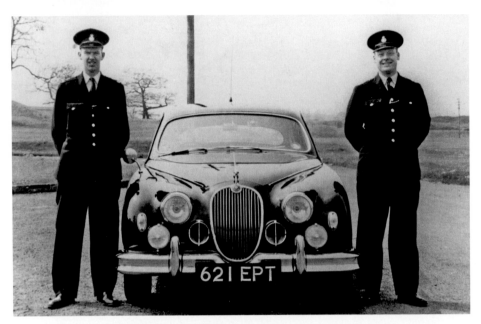

PC Dennis Dunnill and William Hall (right), with the Durham County Constabulary's new Jaguar, purchased to combat speeding motorists on the new stretch of the A1 motorway, *c.* 1959.

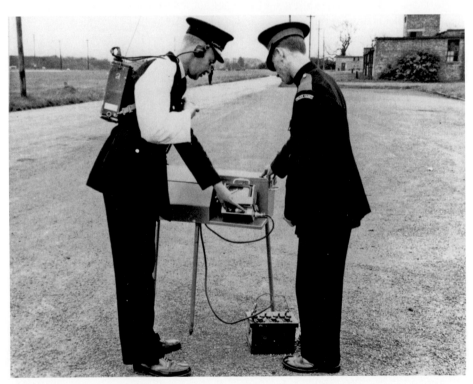

PC Dennis Dunnill and Police cadet Alan Harle (right), with the county's first radar machine (speed trap) for catching speeding motorists, *c.* 1959.

SECTION SEVEN
Occasions & Events

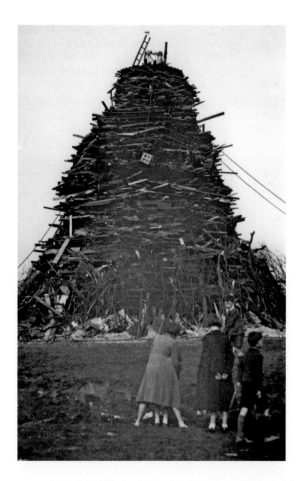

This beacon was erected on Shincliffe Bank Top by the scouts for the celebrations of King George V's Jubilee, 6 May 1935. Events, arranged by the parish council were held throughout the day, finishing with the lighting of the beacon at 10 p.m. Beacons were lit the whole length of England; there were twenty-nine in County Durham.

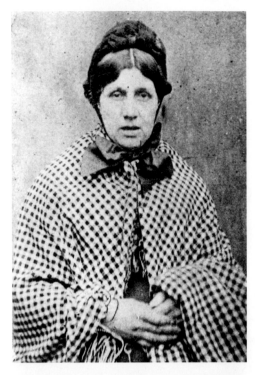

The infamous Mary Ann Cotton, photographed while in Durham Prison by John Stoddart, Shaw-wood Gardens, North Road, Durham, *c.* 1872. She was tried at the Durham Spring Assizes in 1873 for the poisoning of her stepson, although it was believed she had also murdered (over a period of several years) at least another fourteen or fifteen people close to her. She was hanged on 24 March 1873 and buried within the prison walls at Durham.

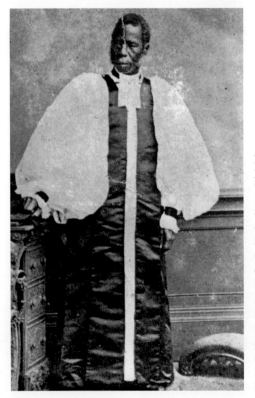

A studio portrait of Samuel Adjai Crowther, Bishop of the Niger Territories, taken by W.J. Hodgson, of Sunrise Cottage, Claypath, August 1888. He, along with other bishops, had come from the third Lambeth Conference as a guest at Auckland Castle. Bishop Lightfoot had invited them to celebrate the recent restoration of Auckland Chapel: on 31 July the University conferred the honorary degree of Doctor of Divinity on Bishop Crowther and ten of his fellow bishops. Born in Ochugu, West Africa in about 1809, he was carried off as a slave in 1821, rescued by a British man-of-war put ashore at Sierra Leone. There he entered the Church Missionary Society schools, was baptised, ordained and eventually consecrated as bishop in 1864.

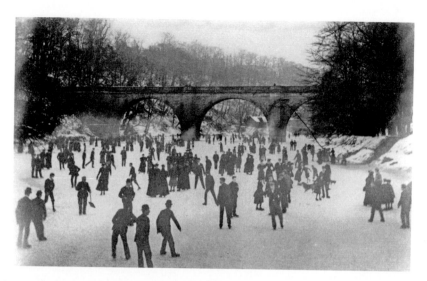

Skating on the Wear near Prebends Bridge during the 'Great Freeze', 1895, when the river was frozen for several weeks. Over 200 people can be seen enjoying themselves on the ice in this photograph by F. W. Morgan.

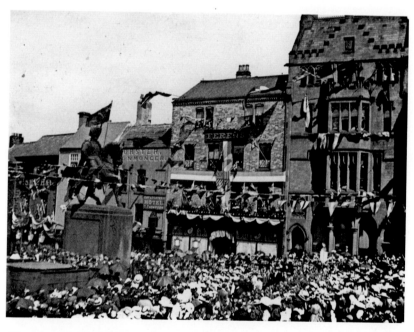

Queen Victoria's Diamond Jubilee celebrations in Durham Market Place, 22 June 1897. The whole of the city was ablaze: with flags, shields depicting the Queen and masses of floral bunting. All children were given a bag of cakes and a commemorative mug. The *Durham County Advertiser* devoted two full pages to describe both national and local celebrations. In the evening the Wear was alight with an illuminated boat procession from Prebends Bridge to The Racecourse. Bonfires were lit throughout the city. A huge fire was lit on the old pit heap ('the duff heap' of Kepier Colliery) on Sunderland Road.

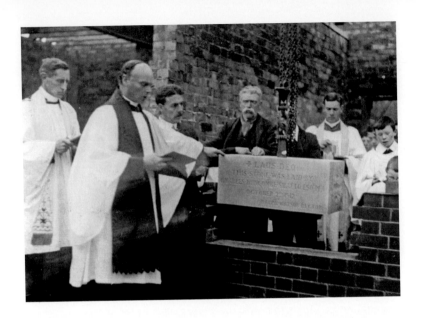

The laying of the foundation stone for St Margaret's parish hall, Crossgate by Charles
Duncombe Shafto, 2 October 1912. The rector, on the left, is the Revd Ralph Watson. The site
had been purchased at a cost of £520 and the building was designed by W. H. Wood of 47
North Bailey at a cost of £2,065 6s 11d. The new hall was formally opened by the Dean of
Durham, Dr Herbert Hensley Henson, on 2 April 1913.

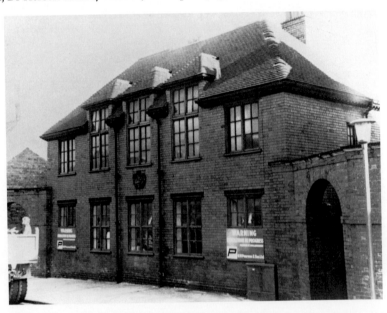

St Margaret's parish hall shortly before demolition in September 1974. The site was later
cleared to build flats for the Three Rivers Housing Association. The hall was the Company
Headquarters for the Church Lads' Brigade from April 1913 to January 1974. An upstairs
room was used by St Margaret's Billiards Club. A new church centre was established in the
former St Margaret's Infants School, Margery Lane.

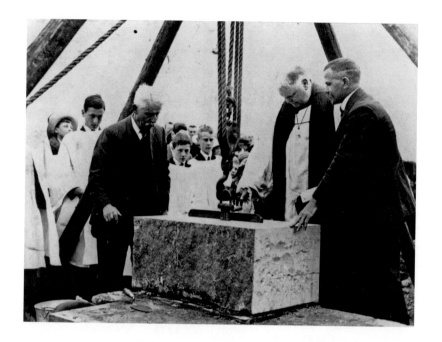

Laying of the foundation stone of Durham School Chapel by Dean Welldon, 3 July 1924. The chapel was built as a memorial to those past pupils who fell in the First World War, 1914-18; their names are inscribed on the stone pillars of the nave (those of the Second World War were added later).

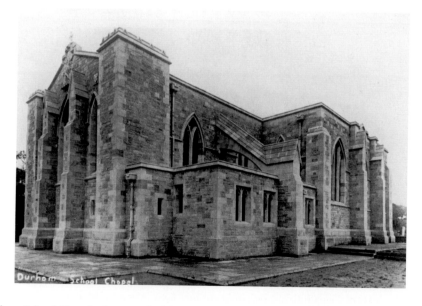

Durham School Chapel, photographed by John Edis. It was designed by W H. Brierley and consecrated on 30 September 1926 by the Bishop of Durham, Dr H. Hensley Henson. The original steps leading up to the chapel were laid to commemorate each Old Dunelmian who died on active service during the 1914-18 war (these were relaid in 1954).

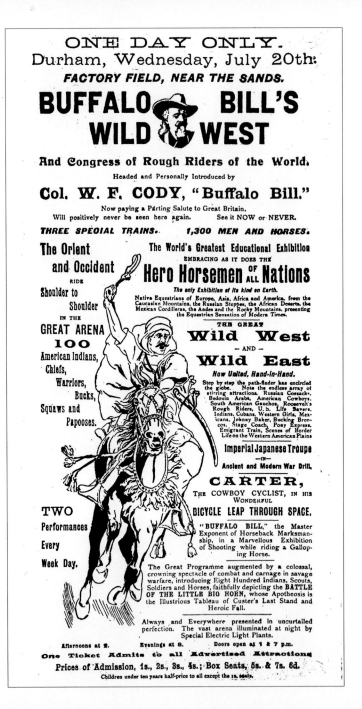

ONE DAY ONLY.
Durham, Wednesday, July 20th.
FACTORY FIELD, NEAR THE SANDS.

BUFFALO BILL'S WILD WEST

And Congress of Rough Riders of the World.

Headed and Personally Introduced by

Col. W. F. CODY, "Buffalo Bill."

Now paying a Parting Salute to Great Britain.
Will positively never be seen here again. See it NOW or NEVER.

THREE SPECIAL TRAINS. 1,300 MEN AND HORSES.

The Orient and Occident RIDE Shoulder to Shoulder IN THE **GREAT ARENA**

100 American Indians, Chiefs, Warriors, Bucks, Squaws and Papooses.

TWO Performances Every Week Day.

The World's Greatest Educational Exhibition
EMBRACING AS IT DOES THE

Hero Horsemen OF ALL Nations

The only Exhibition of its kind on Earth.

Native Equestrians of Europe, Asia, Africa and America, from the Caucasian Mountains, the Russian Steppes, the African Deserts, the Mexican Cordilleras, the Andes and the Rocky Mountains, presenting the Equestrian Sensation of Modern Times.

THE GREAT

Wild West – AND – Wild East

Now United, Hand-in-Hand.

Step by step the path-finder has encircled the globe. Note the endless array of stirring attractions. Russian Cossacks, Bedouin Arabs, American Cowboys, South American Gauchos, Roosevelt's Rough Riders, U. S. Life Savers, Indians, Cubans, Western Girls, Mexicans, Johnny Baker, Bucking Broncos, Stage Coach, Pony Express, Emigrant Train, Scenes of Border Life on the Western American Plains

Imperial Japanese Troupe
—IN—
Ancient and Modern War Drill.

CARTER,
THE COWBOY CYCLIST, IN HIS WONDERFUL

BICYCLE LEAP THROUGH SPACE.

"BUFFALO BILL," the Master Exponent of Horseback Marksmanship, in a Marvellous Exhibition of Shooting while riding a Galloping Horse.

The Great Programme augmented by a colossal, crowning spectacle of combat and carnage in savage warfare, introducing Eight Hundred Indians, Scouts, Soldiers and Horses, faithfully depicting the BATTLE OF THE LITTLE BIG HORN, whose Apotheosis is the Illustrious Tableau of Custer's Last Stand and Heroic Fall.

Always and Everywhere presented in uncurtailed perfection. The vast arena illuminated at night by Special Electric Light Plants.

Afternoons at 2. Evenings at 8. Doors open at 1 & 7 p.m.

One Ticket Admits to all Advertised Attractions

Prices of Admission, 1s., 2s., 3s., 4s.; Box Seats, 5s. & 7s. 6d.

Children under ten years half-price to all except the 1s. seats.

A poster advertising the arrival of Buffalo Bill's (the original Col. W.E. Cody) Wild West Show, and his congress of rough riders of the world, 20 July 1904. Although advertised as being held in the Factory Field near The Sands it was, in fact, held in the Engine Field near Elvet colliery. The arena held 16,000 covered seats and the show included 800 men and 500 horses. The *Durham County Advertiser* reported that 'through the kindness of Col. Cody, the children at Durham Union Workhouse were permitted to attend the afternoon performance'.

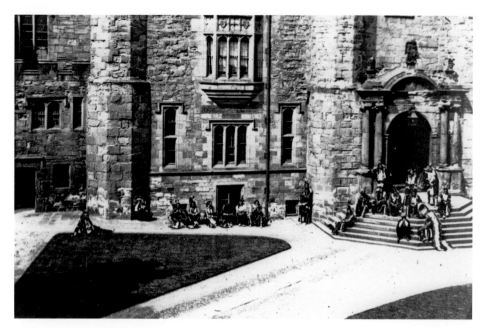

Native American Indians in full war dress, part of Buffalo Bill's Wild West Show, photographed in the courtyard of Durham Castle on the morning of 20 July 1904. The *Durham County Advertiser* reported that some of the Indians were said to have taken part (on the Indian side) at General Custer's Last Stand. This photograph is one of several taken at the time by Mrs Gee, wife of the Master of University College (see p. 98).

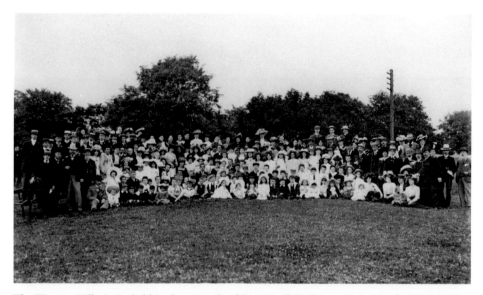

The Western Hill picnic, held in the grounds of Springwell Hall (now St Leonard's RC School), to celebrate the Coronation of King Edward VII, August 1902. The residents of Western Hill and vicinity were not in the area controlled by the Durham Festivities Committee so they had to organise their own events which were described as a huge success in the *Durham County Advertiser* of 15 August 1902.

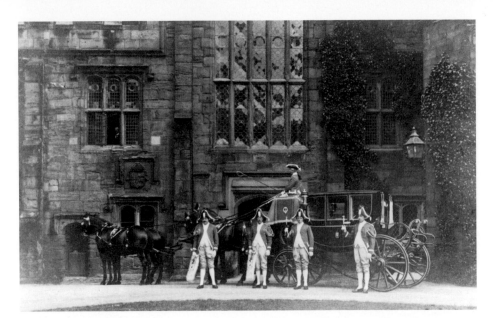

The Assize Coach, with coachmen, in the courtyard of Durham Castle, *c.* 1910. The Assize Judge was conveyed to the Court each day by coach. Negotiating the Saddler Street-Elvet Bridge corner (see p. 37) drew spectators to see how skilfully the coachman manoeuvred 'the heavy state coach and four mettlesome bays' round it. The Castle accounts for 1913 reveal the great expense at which the Judge was kept: his lodgings for June cost £140, enough at that time to buy a small terraced house.

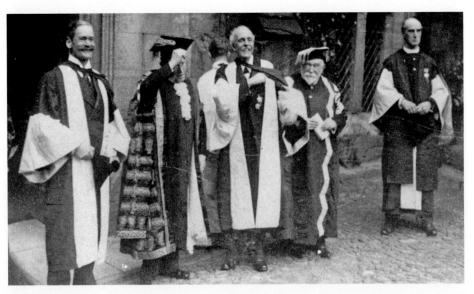

A group photographed in the Castle courtyard, after the conferring of honorary degrees — Doctor of Civil Law on two of them, 4 November 1913. Left to right: John George Lambton, Earl of Durham, DCL; the Chancellor of the University, His Grace Henry George Percy, Duke of Northumberland; Mr Arthur James Balfour (Prime Minister, 1902-5), DCL; Sir George Hare Philipson, Pro-Vice-Chancellor; and the Revd Dr Henry Gee, Vice-Chancellor and Master of University College.

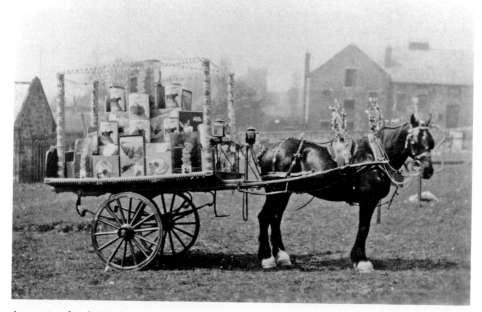

An entrant for the Durham City Horse Parade on the Barracks Field, 1920s. Wood & Watson's factory is on the right and on the left is the old powder house belonging to the Militia barracks (Vane Tempest Hall). In the distance is the tower of St Giles' Church. The first horse parade recorded was a small affair organised by Dr Edward Jepson, then in his second term of office as mayor, in 1896.

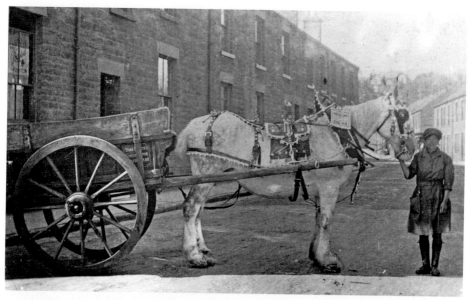

A cart belonging to T. Coates, builder and general contractor, 11 Mountjoy Crescent, decorated for the Durham City Horse Parade, 1920s. This photograph was taken outside the Colpitts Hotel in Cross Street (now incorporated into Hawthorn Terrace), which was named after the man who opened it, John Colpitts.

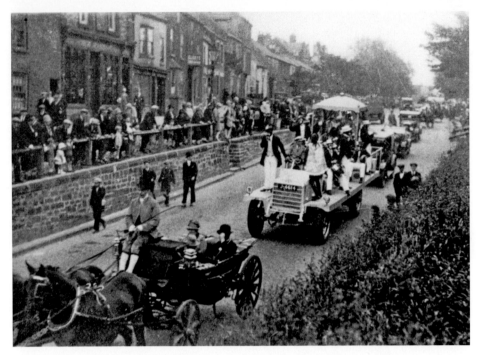

Durham City Carnival Parade, travelling towards Gilesgate Bank, July 1927. The event was arranged by the Mayor F.W. Goodyear to help raise funds for the castle restoration fund. On the left is the Brewers' Arms.

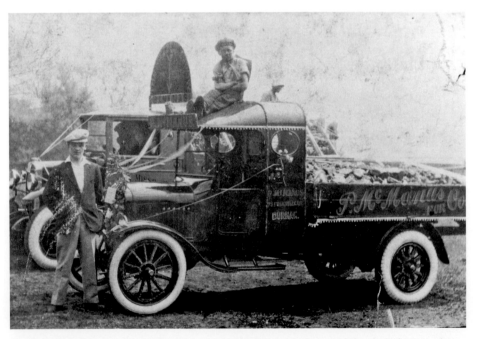

McManus' coal wagon from Sidegate, c. 1927. The wagon is decorated for the Whit Monday Parade, also known as the Durham City Horse Parade.

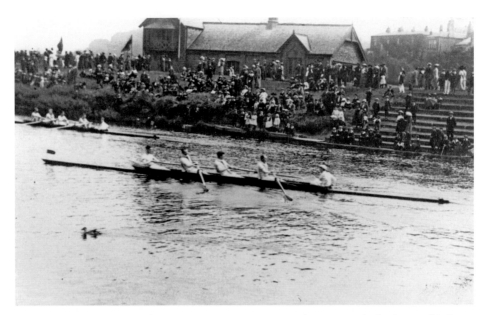

Durham Regatta, *c.* 1913. The two crews are rowing up to the start. In the background is St Cuthbert's boathouse built in 1894. The regatta in its present race form (i.e. boat races) was established 1834, developing from a Procession of Boats, first held in 1815 to celebrate the Battle of Waterloo.

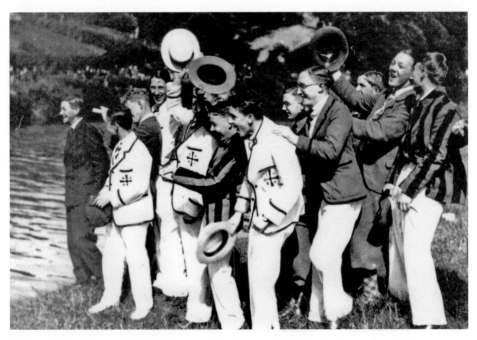

Durham School boys on The Racecourse, cheering on their crew in the regatta, 25 June 1930. Left to right: L.H.A. Howe, A.C. Bell, R.W.R. Mackenzie, H.L. Hunter, E.W. Arnott, E. Williams, C.W.S. Thomas, L.I. Thomas, G.G. Bolton, G.C.C. Blakstad, I.H. McLaren, H.L. Smeddle and K.A. Clark.

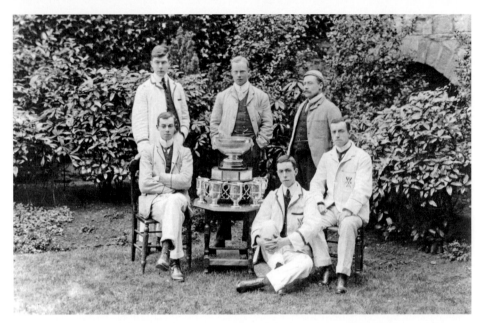

University College (Castle) Boat Club crew, winners of the Senate Cup, 1903. Back row, left to right: E. Dodd, H.L. Lloyd, Mr E.J. Lewis (coach). Front row: A.T. Hall, J. Harper (cox), F. Stone.

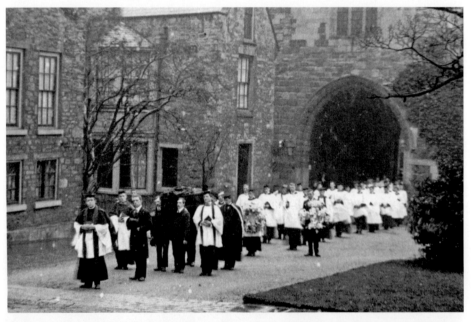

The funeral procession for Jesse Parsons who drowned in the Wear, 24 February 1911. He was the cox of St Chad's graduate crew, a native of Newtown, Newfoundland. During bad weather the crew got into difficulties at the Ash Tree (the starting point for the races), near Pelaw Wood. When the boat became swamped the crew swam to the bankside. After a few minutes it was noticed that the cox was not with them. The cortège is seen entering The College from the South Bailey for the funeral service in the Cathedral. The burial took place in Elvet Hill churchyard.

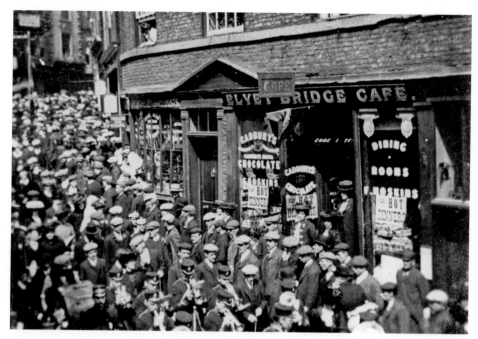

One of the earliest known photographs of the Durham Miners' Demonstration (later called the Gala), travelling towards Elvet Bridge from Saddler Street, June 1905. On the right is the Elvet Bridge Café. Membership of the Durham Miners' Association at the end of 1904 was 89,914. By the end of June 1905 its fund stood at £322,970 14s 8d.

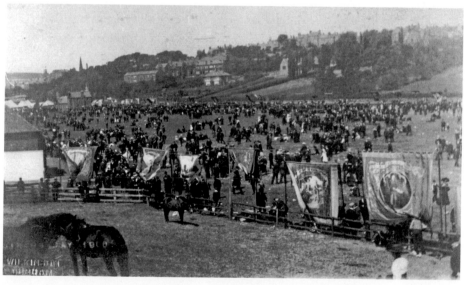

The Racecourse on Miners' Gala Day, 1908. The pit ponies in the field were brought in for the day as mascots to lead in the banners. In July 1899 a movement was started by the wife of Dean Kitchin for the promotion of kindness to pit ponies. The first Gala was held at Wharton Park, 12 August 1871, with an estimated crowd of 5,000.

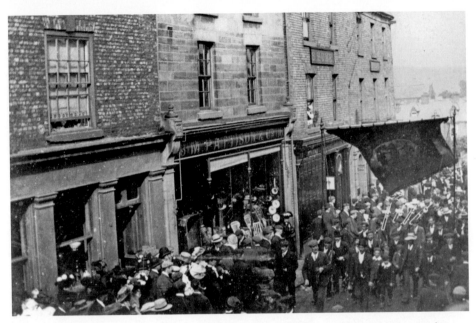

Miners and their banners, 1905 Gala, travelling back from Elvet on their way home. In the centre can be seen the premises of Pattison, the cabinet makers and upholsterers, and Samuel Hume, the jeweller.

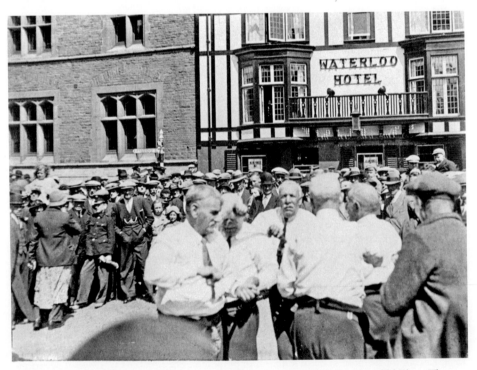

Sword dancers during the 1938 Miners' Gala, outside the Waterloo Hotel in Old Elvet. The Waterloo was demolished in about 1970-71 to make way for the new Elvet Bridge.

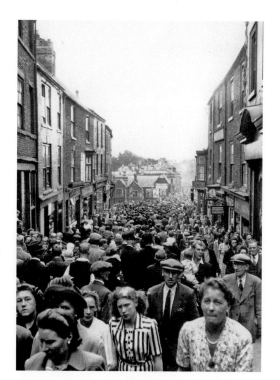

The Miners' Gala, looking towards Elvet Bridge, the year the collieries were nationalised, 1947. The 1940s saw the crowds at the Gala reaching their peak, when a quarter of a million miners and their families came to Durham. The numbers lessened in the 1950s, as some mines were closed. Today there are no working deep coal mines left in the country.

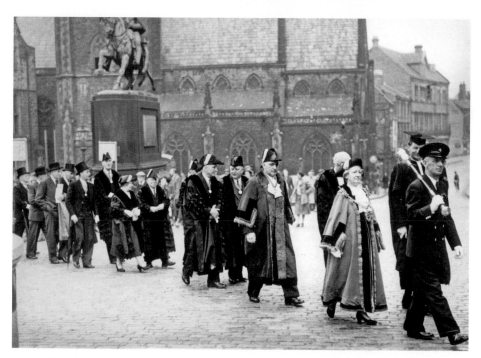

Mrs Evelyn Blyth, the second woman Mayor of Durham, walking through the Market Place to the Cathedral in her first civic procession as mayor, 26 May 1954. The first woman mayor was Councillor Mrs Hannah H. Rushford in 1950-51 (see p. 32).

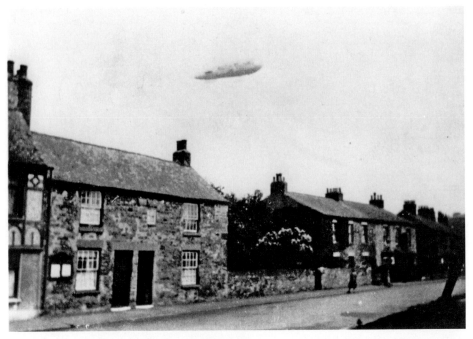

An unidentified airship travelling over New Elvet near the New Inn, Stockton Road, late 1930s.

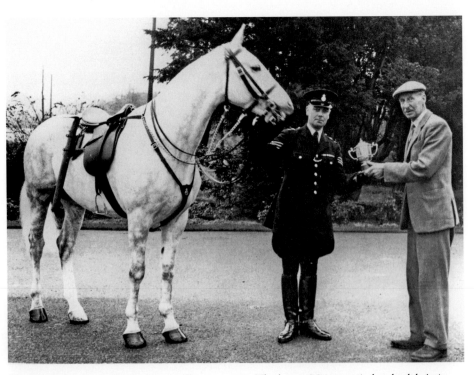

The Best Police Horse in the County Show, *c.* 1959. The horse, Montrose (a local celebrity), and its rider, Harold Clarkson.

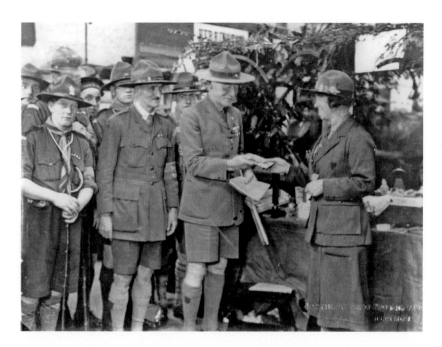

The Chief Scout, Lord Baden Powell, on his visit to Durham, 18 19 October 1932. He is seen here buying a calendar from the local association stall at the County Scout Bazaar, Durham Indoor Market. The lady on the right is a Mrs Carter. Lord Baden Powell had been in the north-east for the Jamboree held at Raby Castle. He died in 1942.

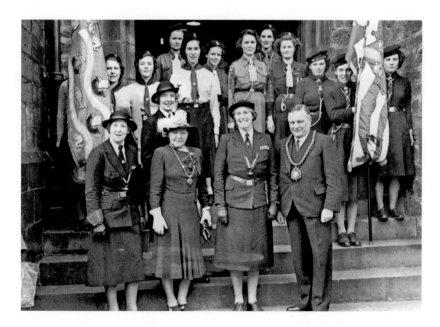

Lady Baden Powell (front row, third from the left), standing on the steps of the Town Hall with the Girl Guides and Sea Rangers, *c.* 1949. The Mayor is Cecil Ferens and the Mayoress (second from the left) is Mrs Ferens, his mother.

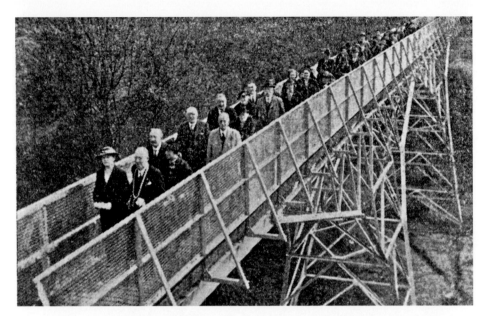

The opening of the Silver Link footbridge linking Gilesgate to Pelaw Wood, 12 April 1938 (*Durham County Adveriser*). Among the civic party walking over the bridge are the Mayor, Councillor W.E. Bradley, and Alderman J.T.E. Dickeson, Chairman of the Parks Committee. The bridge, designed by Mr Green, city surveyor and engineer, was based on the one which spans the Zambezi Falls. It was constructed by the Cleveland Bridge Company of Darlington, the cost of the steel work being £805.

A group of Jarrow marchers at the Farewell Hall feeding station, on their way to London, 9 October 1936. Following the closure of the shipyards in the mid-1930s and the subsequent years of deprivation, 200 men set out from Jarrow on a 300-mile walk to the Houses of Parliament to hand in a petition. Despite their efforts the petition was never accepted.

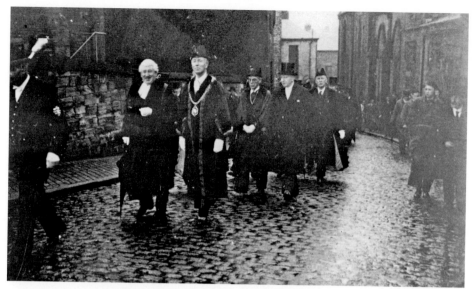

The visit of the German Ambassador, Joachim von Ribbentrop (wearing top hat), to Durham, 15 November 1936. Ribbentrop had been staying at Wynyard Hall as a guest of the Mayor, Lord Londonderry. Here the party is walking up Owengate for the civic service in the Cathedral. Hundreds of people had crowded into the city streets to witness the mayoral procession from the ancient Guildhall to the Cathedral. After the Second World War Ribbentrop was tried at the Nuremberg War Trials and hanged as a war criminal in 1946.

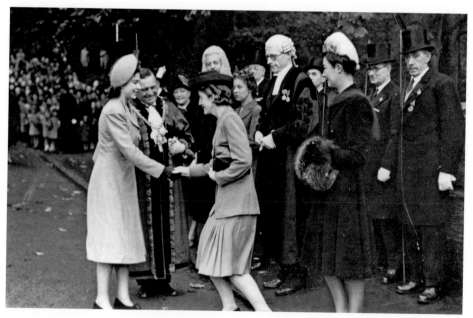

Princess Elizabeth on her visit to Durham to lay the foundation stone of St Mary's College (see p. 68), 23 October 1947. The Mayor, Cecil Ferens, is presenting Mrs George Bull, wife of the town clerk, to the princess. Mr Bull, wearing glasses, is standing behind. The mayor's bodyguard can be seen in the rear, wearing top hats.

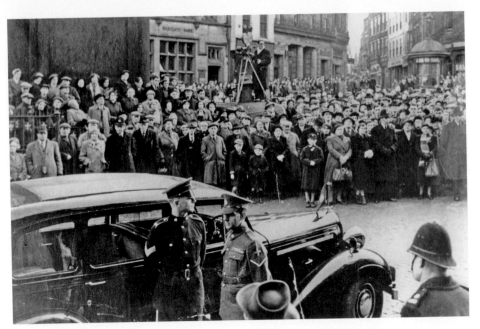

Crowds in the Market Place to witness the Honorary Freedom of the City being given to Field Marshal Viscount Montgomery, 14 January 1953. In the centre, on top of the van, is a Movietone camera capturing the event for the cinema audience. 'Monty' became the sixteenth Honorary Freeman of the city. The Mayor, Councillor Gordon McIntyre, presented him with a vellum inscription, contained in an oak casket, made from an old beam from the Cathedral.

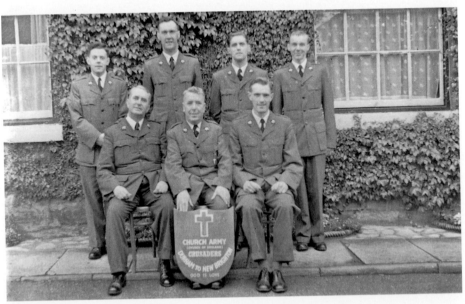

A group of Church Army officers, before their Durham to New Brighton Crusade, July 1954. This organisation was founded in 1882 by Wilson Carlile on the model of the Salvation Army. The names Stanley F. Dakin and Raymond W. Milner are written on the reverse of the photograph.

SECTION EIGHT
Defence Of The Realm

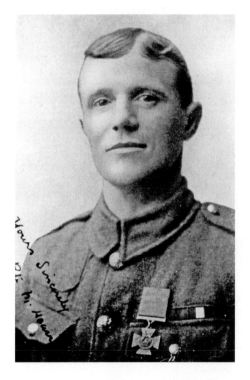

Private Michael Heaviside, 15th battalion, Durham Light Infantry, was born at 4 Station Lane, Gilesgate on 28 October 1880. His grandfather was Thomas Heaviside, local photographer. During the Boer War Michael was a private with the Royal Army Medical Corps. Later, while he was a miner at Craghead, he joined the 4th Durham Light Infantry as a reservist. At the outbreak of the First World War he was transferred to the 15th DLI. This photograph shows him wearing the Victoria Cross awarded to him in recognition of his actions at Fontaine-les-Croisilles, France, on 6 May 1917. Underfire he took food and water to a wounded man only yards from the enemy lines. He was presented with his VC at Buckingham Palace, 21 July 1917. He died on 26 April 1939 and in the late 1940s a street on the newly built council estate in Gilesgate was named Heaviside Place in his honour.

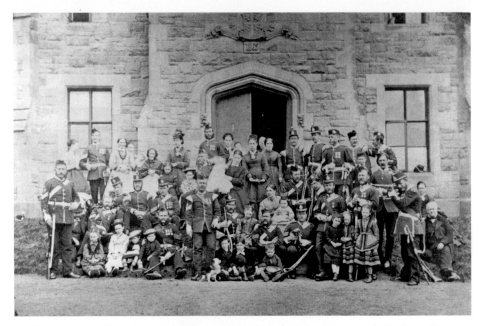

Staff Sergeants of the 2nd North Durham Militia, with their families, outside the barracks (Vane Tempest Hall), Gilesgate, *c.* 1876. Living accommodation was provided at the barracks for some non-commissioned officers.

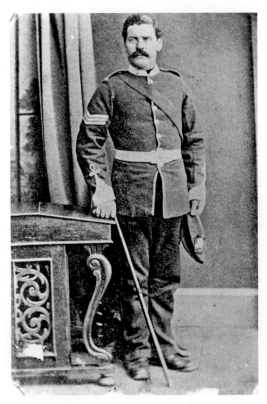

Sgt Michael Kelly, in the uniform of the North Durham Milltia, 1870s. Born in County Wexford in 1842, he served twenty-one years in the army, including ten years in India, most of the time with the 38th Regiment of Foot. For the last five years of his service, 1876-81, he was a sergeant in the North Durham Militia at Gilesgate Barracks. Between 1884 and 1890 he kept the Blue Bell Inn in Framwellgate. He was the grandfather of Desmond Kelly of Gilesgate Moor, well-known local photographer.

Recruits for the Durham Pals outside Cocken Hall, near Leamside, September 1914. Later, because of overcrowding, they were moved on to Newton Hall. On 14 July 1914 an attempt had been made by the suffragettes to burn it down *(Durham Directory & Almanack* (1915), p. 52).

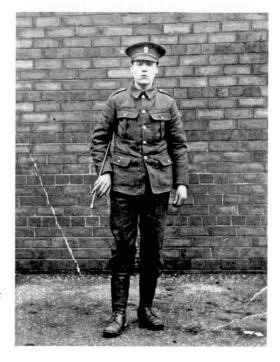

Private William Savage, the author's great-uncle, 'C' Company, 2nd Tyneside Irish Battalion, 25th (Service battalion) Northumberland Fusiliers, November 1914. Of the strength of this battalion, 75 per cent were recruited from the Durham area. William enlisted from his home address which was then Bell's Ville (see p. 2). William was one of the lucky ones. He survived the massacre of the Somme on 1 July 1916, when most of the battalion were killed. He himself was wounded, October 1916.

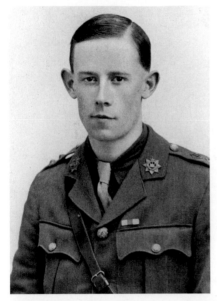

The war poet, Lt William Noel Hodgson, Military Cross, a former pupil of Durham School (1905-11), who was killed 1 July 1916, with the 9th Devonshire Regiment. He was buried with his comrades where they fell, now named the Devonshire Cemetery, near Mametz Wood. He was the son of the Bishop of St Edmundsbury and Ipswich. His *Verse and Prose in Peace and War* (London, John Murray, 1916) contains several poems recalling his days in Durham:

Above the graves of heroes
The wooden crosses grow
That shall no more see Durham
Nor any place they know.

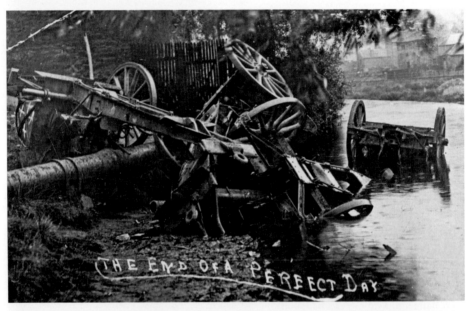

'The End of a Perfect Day', 29 June 1919. Captured German field guns lie in the Wear behind Martin's Flour Mill on the morning after the Treaty at Versailles was signed. (In December 1918 four guns had been given to the city as war trophies by the Northumberland Fusiliers.) An unofficial celebration took place in the Market Place and when the pubs turned out demobbed soldiers and sailors seized the guns and proceeded to pull them round the Market Place, singing patriotic songs. Some of them had the idea of throwing them in the river. They were then pulled down Walkergate (Palace Lane); the first gun crashed through the doors of the Palace cinema, to the great annoyance of those inside. Soon they were back *en route* for the river, where difficulty was experienced in getting them over the sewer pipe and then into the river (*Durham County Advertiser*).

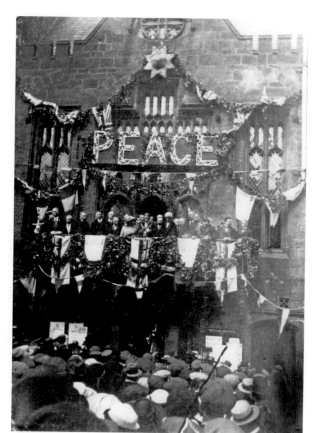

The declaration of peace was proclaimed from the Town Hall balcony to the citizens of Durham on the afternoon of 19 July 1919, by the Mayor of Durham, Alderman Proctor. The *Durham County Advertiser* reported that at Gilesgate and Millburngate the residents were parading stuffed effigies of the Kaiser. In the afternoon, sports were held on The Racecourse for the children and the evening was rounded off by a huge bonfire on The Sands, lit by the Mayoress.

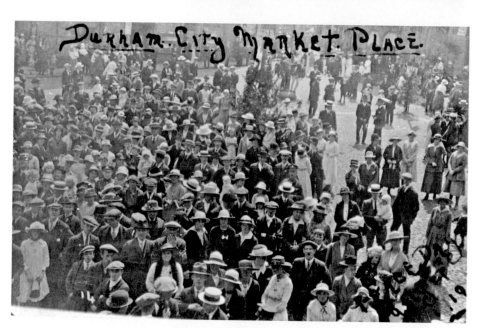

The crowds in the Market Place during Peace Day, 19 July 1919.

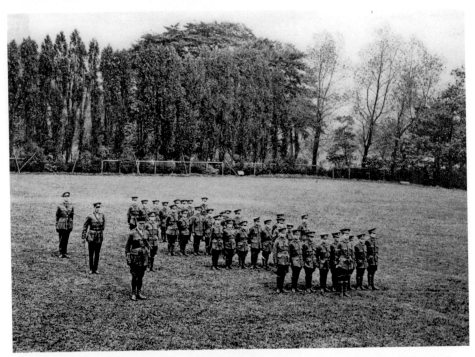

Bow School Cadets on parade on the school field after the First World War. The Cadets had been founded in 1914 with ninety boys. The school now has a Combined Cadet Force.

St Oswald's War Memorial, on the day of its unveiling, 13 March 1921. It was dedicated by Bishop Henson and unveiled by Mrs Roberts of Hollingside Hall, who had lost two sons in the war. The cross was erected at a cost of £300. Three bronze tablets around the base record the names of ninety men from the parish. (Two were stolen in the autumn of 2009.)

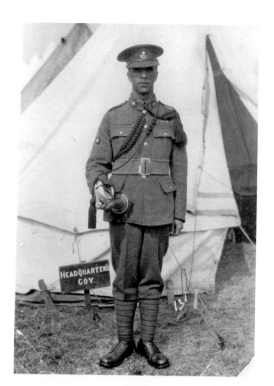

Bugler Thomas Carr, 8th battalion, Durham Light Infantry, wearing his campaign medals from the First World War, photographed at the annual camp, c. 1929. He spent his working career with the Durham City Parks Department.

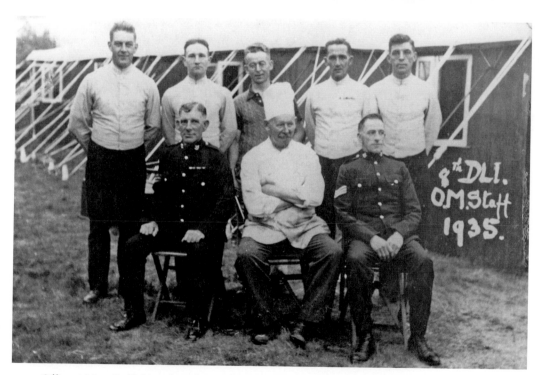

Officers' Mess Staff, from the 8th Battalion, Durham Light Infantry, photographed at the annual camp, Catterick, 1935. In the middle of the back row is William Rudd of Hetton le Hole.

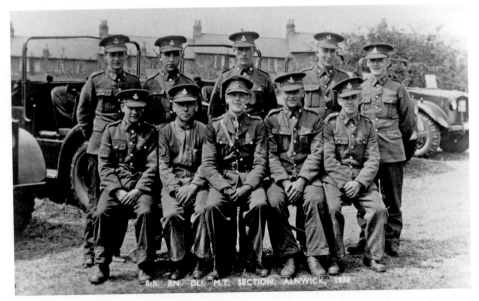

Motorised Transport Section, 8th Battalion, Durham Light Infantry, at Alnwick, 1938. In the front row, second from the right, is Bob Ashworth of Gilesgate. In April of that year the *Durham County Advertiser* reported that twenty members of the Hitler Youth Movement arrived in Durham as part of their cycle tour from Hull to Durham to study the life of the English people. While in Durham they stayed at the Gilesgate Youth Hostel and spent two days visiting the Cathedral, Castle and town hall.

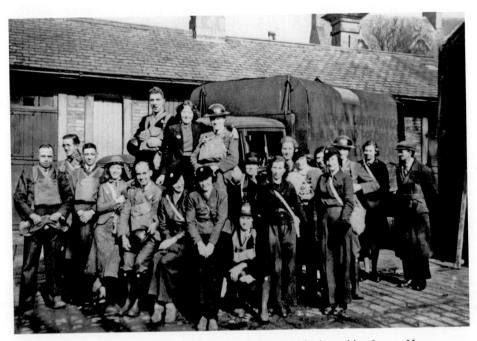

Durham County Council Emergency Ambulance Team, outside the stables, Leazes House, Claypath, 1939. It is interesting to note that they are all carrying gas masks.

An unknown member of the Observer Crew at Durham, 1939. Durham was very fortunate not to have suffered like many other northern towns. Civil Defence records belonging to the ARP, held at Durham Record Office, recall very few incidents. In August 1940 high explosive bombs were dropped at Framwellgate Moor and Shincliffe. This photograph and the one below were taken by Mr D.E. Webster (see p. 28).

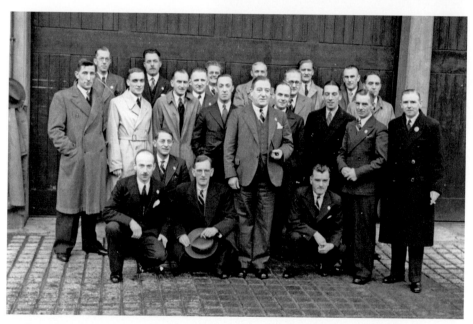

Durham City No. 30 Group Observer Corps, 1939. A Crew, pictured here, included the following: District Controller A. Rutherford, Assistant District Controller J.T. Harrison, R. Marshall, E. Dodsworth, F. Greenwood, E. Dixon, J. Dockray, J.W. Deighton, J. Vince, H.G. Thompson, G. Spirit, J. Volkman, J. King, F. Lax, J.W. Leadbeater, B.W. Donkin, G.L. Dunlop, H. Fairless, R.E. Sadler, W.N. Thompson, J. Naylor and J. Owen.

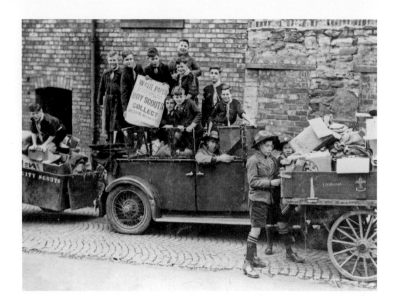

The 5th Durham Scouts collecting books and waste paper for the war effort in 1939. 'Skip' Chalmers is seated at the wheel of his car. By June 1944 £300 had been raised for the Red Cross Fund. The paper dump was in Court Lane and operations began on 14 October 1939. The 5th Durham Scouts were also involved as messengers for the ARP, the County HQ of which was in Hallgarth Street, and the City HQ in Allergate.

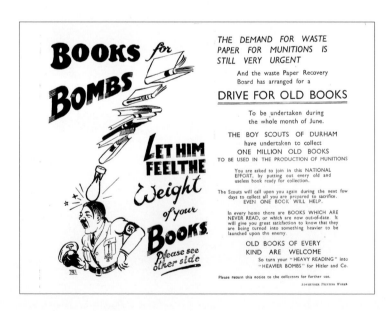

A poster delivered to every household in the city by the 5th Durham Scout Troop, asking for waste paper and books. During the first months of the war it seemed possible that enemy air raids might attempt to set alight the unharvested crops. Scouts were therefore asked to help in watching for fire during air raids. Six scouts from the troop were allocated to Byers Garth Farm near Sherburn, on 'fire watch' (5th Durham records).

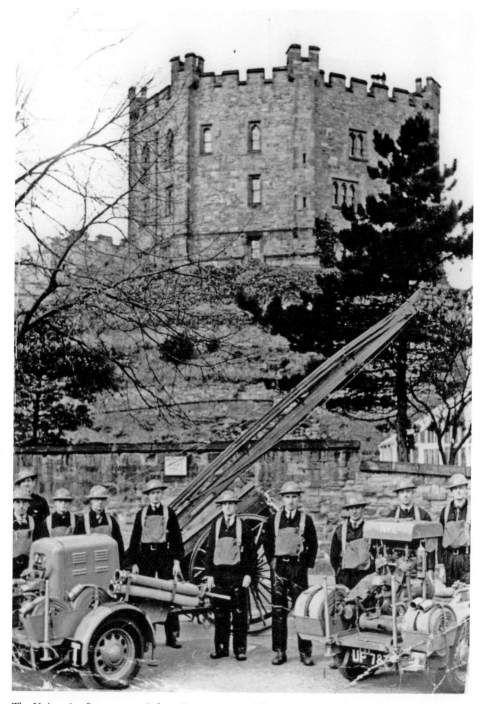

The University fire crew on Palace Green, *c.* 1940, The crew was made up of non-academic University staff.

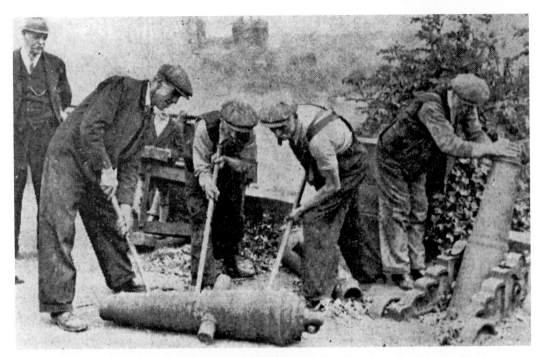

The removal of the cannon from the Battery, Wharton Park, to be melted down for the war effort, 2 August 1940. Generations of city children had enjoyed climbing and sitting on these.

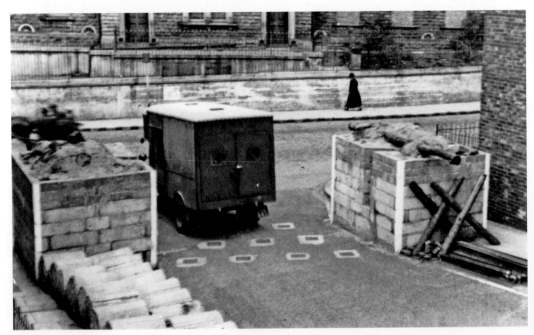

A rare photograph of road defences at the bottom of the Avenue during the Second World War. Civilians were not allowed to take photographs of this nature. It is interesting to see the Dad's Army-type van. The building to the rear is the former St Margaret's Hospital.

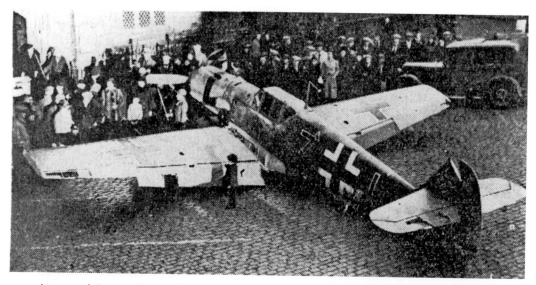

A captured German Messerschmitt in Durham Market Place during War Weapons Week, 16-23 November 1940. War Weapons Week raised over £174,000 from the Durham City, Brandon and Spennymoor districts. The plane is facing St Nicholas' Church.

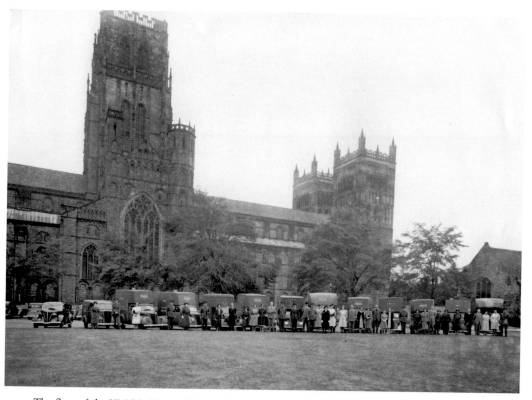

The fleet of the YMCA (Young Men's Christian Association) mobile kitchens, Palace Green, during the Second World War.

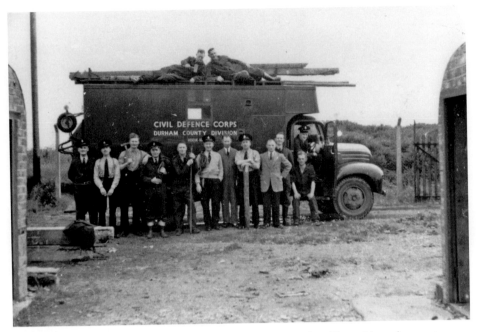

Durham Prison Officer Section of the Civil Defence Corps at the old munitions dumps at Brasside, late 1950s.

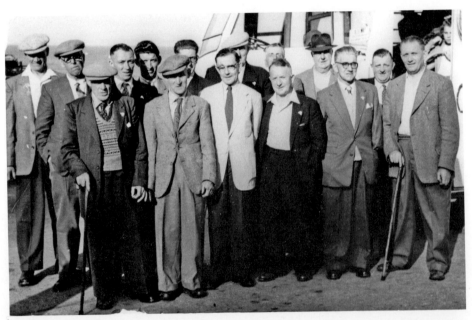

The British Limbless Ex-Service Men's Association (BLESMA) outing, 1950s. T. Parkin and Harold Readman are in the front row to the left and on the far right is A. Davis; behind him to the left is Freddie Dixon. The association was founded in 1932 to promote the welfare of all those of either sex who had lost limb(s) or eye(s) as a result of service in any branch of HM forces.

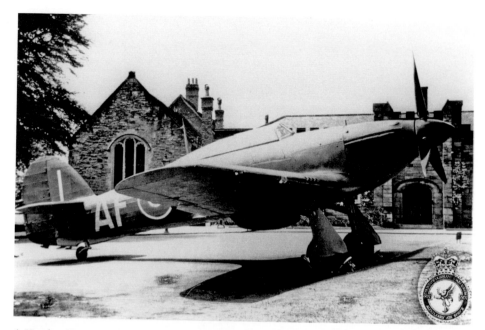

A Hawker Hurricane MkI P2617 on Palace Green during the consecration and laying up of the Standard of 607 County of Durham Fighter Squadron, Durham Cathedral, 22 May 1960. The standard was hung over the squadron's war memorial in the south transept, commemorating the weekend fliers and ground crew who fought alongside the regular RAF air crews in the Second World War. The squadron flew against the first German raid of the war over Britain. The Hurricane now stands in the Battle of Britain Hall, RAF Museum, Hendon.

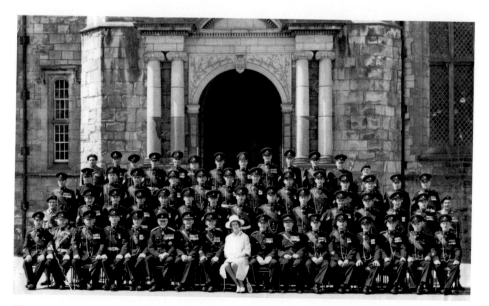

Warrant Officers and NCOs from the 8th Battalion, Durham Light Infantry outside the main door of Durham Castle with their Colonel-in-Chief, Princess Alexandra. The occasion was the laying-up of the old Colours in the Cathedral, 18 October 1964.

The author, Michael Richardson, next to the gnarled hollow trunk of an old oak set up by the side of the path leading to Count's House, March 1997. The trunk was originally much taller and wider but over the years it has been subjected to vandalism. A recent discovery of old newspaper cuttings revives a forgotten folk-tale. King David II of Scotland had concealed himself in this tree, then growing by the side of the River Browney, after his defeat at the Battle of Neville's Cross in 1346. The king then moved along the riverside to the old bridge at Aldin Grange where he was taken prisoner. This is the only mention of the story and I suppose we will never know the truth of it. However, Canon H.B. Tristram, a noted naturalist, had heard the story when he was a boy at Durham School. As the trunk was in danger of breaking up when he saw it, around the turn of the century, he brought it to the riverbanks at Durham for safety.

Acknowledgements

So many people have donated photographs that it is impossible to thank them individually. Special thanks go to Miss Dorothy M. Meade, David R. Williams, George Nairn, Roger Norris, John Austin, Des and Audrey Kelly and Steve Shannon.

The staff of the following institutions have helped in various ways: Durham University Library, Palace Green; Durham City Reference Library and Durham Record Office.

Without their assistance, this book would never have been possible. Many readers have new material or information, they should contact Michael Richardson, 128 Gilesgate, Durham, DH1 1QG (0191 3841427) gilesgatearchive@aol.com.

Also available from Amberley Publishing

*Around Durham
Through Time*
Michael Richardson

ISBN 978-1-84868-557-4
£14.99

Available from all good bookshops or order direct
from our website www.amberleybooks.com